IMAGES
of America

SHOREVIEW
MINNESOTA

57.03 a. F & H. Bucher 56.13 a. F & H. Bucher 56.09 a. 55.30 a. Susannah J. Becker 53.72 POPLAR LAKE

C. D. Gilfillan 80 a. Isaac Bernheimer & Arnold 80 a. Christian S. Anderson 47.255 a. Lewis Engles 47.255 a. John & Erick Ostman 10.28 a.

2 1 Lewis Engles 20 a. Chris. S. Anderson 20 a.

Thos. Brian 40 a. 40 a. N. Stewart 160 a. 40 a. Lewis Engles 10 a. Jas. J. Hill

N. W. Killson 30 a. LONG LAKE

N. W. Killson 33.35 a. L.5 C. D. Gilfillan 40 a. Isaac Bernheimer & Arnold 160 a. Jas. J. Hill 10 a.

N. W. Killson 33.52 a. L.6 N. W. Killson 40 a. Jas. J. Hill 27.69 a. L.1

RTLE 11 CHARLES 12 LAKE L.1

L.7 30.17 a. L.2

AKE Socrates A. Thompson 80 a. Jas. J. Hill 63.57 a. N. Oliver 14 a.

L.8 36.04 a. PLEASANT LAKE

L.4 32.65 a. Jas. J. Hill 64.44 a. L.3

A. Thompson 160 a. N. Jas. J. Hill 79.53 a.

L.3 36.10 a. Paul Joverszick 40 a. Jas. J. Hill 79 a. 40 a.

14 (6-2) 13 Sch. Ho. #25

W. J. Godfrey 80 a. Angeline Thompson 80 a. Hy. Bucher 40 a.

20 TOWN 30. Plate 18 1886

BEER FARM STOCKY NORTH OAKS WHI W

IMAGES
of America

SHOREVIEW
MINNESOTA

Verna Rusler

ARCADIA

Published by Arcadia Publishing,
an imprint of Tempus Publishing, Inc.
3047 N. Lincoln Ave., Suite 410
Chicago, IL 60657
Printed in Great Britain.

Library of Congress Catalog Card Number: Applied For.

For all general information contact Arcadia Publishing at:
Telephone 843-853-2070
Fax 843-853-0044
E-Mail sales@arcadiapublishing.com

For customer service and orders:
Toll-Free 1-888-313-2665

Visit us on the internet at http://www.arcadiapublishing.com

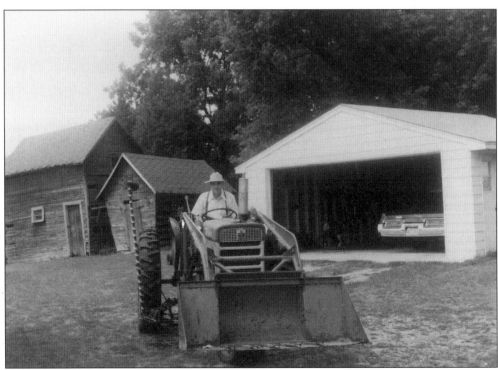

APRIL 23, 2002. Forty-five years of incorporation, and 99 years of Mounds View Township.

CONTENTS

Acknowledgments 6

Introduction 7

1. Indian Territory to 1910 9

2. 1911–1940 37

3. 1941–1956 93

4. Village of Shoreview 111

5. City of Shoreview 119

ACKNOWLEDGMENTS

This book would not have been possible without the assistance and support of the members of the Shoreview Historical Society.

We thank the residents of Shoreview who donated pictures and shared their family histories. The City of Shoreview provided maps and assisted in other ways. We thank the many individuals who provided assistance and support. A special thank you goes to Doris Claeys for access to photographs from the archives she maintains for the Shoreview Historical Society, and to Jacci Krebsbach, President of the Historical Society, for her support and assistance through sharing her knowledge and the diligence in discovering new pictures and information.

INTRODUCTION

Shoreview, Minnesota consists of 12.75 square miles of Mounds View Township. It has seven lakes, numerous named ponds, nine city parks, three county parks, and several areas designated as open spaces within its boundaries. Until 1957 and incorporation, the industry was limited to farms, resorts, bars, and small family businesses. The Village Hall evolved through a series of unique locations and situations. When Shoreview became a city, Shoreview Commons Park was developed to house the City Hall, Library, and Community Center. Shoreview did not and does not have a downtown.

During the early 1800s, the area we know as Shoreview was Indian Territory. The Sioux, Dakota, Chippewa, and Ojibwa Indians roamed the territory between the Mississippi and Saint Croix Rivers. In 1837, the Ojibwa Indians ceded the territory to the government. (The Ojibwe and the Chippewa are the same tribe. The French translated what they heard to be Ojibwe and the British heard Chippewa.) By 1848, the area was known as the Minnesota Territory.

During the winter of 1850, Socrates Thompson, a native of Ohio, captured a large turtle in a lake he named Turtle Lake. At the land office, he was told the site on the lake that he wished to claim had been claimed by Samuel Eaton. Thompson claimed a nearby section not on the lake. With Thompson's help, Samuel Eaton's house was finished in April. His wife and three daughters traveled from Vermont to join him. It took courage for women to join their men in the territory during a time of continual Indian wars. Gipp Carter, a native of Virginia, joined the settlers in 1851. John Ledgergaeber built the first hotel in 1851. He named it the Half-Way House because it was the stage coach stop half-way between Saint Paul, Ramsey County and Columbus, Anoka County. After going bankrupt in 1853, he operated a farm in Mounds View Township. Socrates Thompson and John Ledgergaeber were on the 1865 census. (The tomb stone of Socrates Thompson II, the son of Socrates Thompson, can be seen in Union Cemetery of White Bear Lake.)

During the 1850s, settlers from the Scandinavian countries, Switzerland, England, Ireland, Germany, Poland, and settlers from other states migrated to this area to farm. Common crops

were strawberries, potatoes, corn, wheat, and hay. Because much of the soil was poor or marshy, many of them had dairy farms or raised turkeys and pigs.

Minnesota became a state on May 11, 1858. The area that became Shoreview is in the Township of Mounds View which had a population of 99. The first township election was held at the Socrates Thompson home, and the first board meeting was held there on June 23, 1858.

Dr. Patterson, an Episcopal priest, conducted the first church service in 1861 at the George Gardner home. After the Homestead Act of 1862 and the end of the Civil War, there was an influx of farmers to the township.

During the 1880s, the area became known for its recreational sites. Two entrepreneurs were William Athey, who provided boats and fishing tackle on Snail Lake, and Patrick Powers who rented boats on Lake Johanna.

Cardigan Junction, the switching point for trains on the Soo Line Railroad, was built in 1887. Trains en route to the Twin Cities were uncoupled and routed to one of the 70 sidetrack sites. The individual cars were then reassembled into new trains destined for either Minneapolis or Saint Paul.

Schools were important to the early settlers. School District #4 began serving the area in 1858. Snail Lake School began as the Hill Farm School to satisfy the 1885 law requiring children between the ages of 8 and 16 to attend school for 12 weeks a year. Wilbur Lake School was built in 1891, and the Turtle Lake School in 1895.

During World War I some residents served in the military services. During World War II, both men and women of Shoreview served in the military services or worked at the Twin Cities Army Ammunition Plant on the western border of Shoreview. People living near the arsenal could see the tracer bullets test fired. A Shoreview resident, Arthur Nelson, was killed by a bullet that ricocheted off the bunker at which it had been fired. Women of the area knitted scarves and rolled bandages in a Red Cross Unit named the "500 Club."

A petition for incorporation was presented to the Ramsey County Board on March 14, 1957. After a bitter dispute, the incorporation of the Village of Shoreview was approved by a vote of 853 to 748. The original name proposed was Shorewood. When it was learned there was a Village of Shorewood in Minnesota, the many miles of shoreline caused them to name the Village Shoreview. On May 23, 1957, Kenneth Hanold was elected mayor of the 5231 people in the newly-incorporated Village of Shoreview. Through an act of the State Legislature, Shoreview changed its form of government and became a city, with a population of 14,000, on January1, 1974.

Over the years, the busy intersection of State Highways 96 and Hodgson Road was the center of activities usually associated with a downtown. Early in 1974, plans were made to establish a park in the center of the Village to be named South Turtle Lake Park. When the site near Victoria Street and Highway 96 became a park, it was named Shoreview Commons Park. Forward thinking, long time Mayor Dick Wedell spearheaded a plan to develop a community gathering place in the park. Shoreview Commons became a reality in 1990. City Hall, the Library and a Community Center occupy the center of Shoreview Commons Park.

By the end of the year 2000, the only vestiges of the rural Shoreview remaining were a few summer cabins on the lake shores, a few chicken coops, and sheds. The last remaining barn was demolished in 1999. Ninety-five percent of the 12.75 square miles of Shoreview was built-up. In addition to Shoreview Commons Park, Shoreview has nine city parks, seven lakes, three county parks, and many named ponds and designated open spaces.

One
INDIAN TERRITORY
TO 1910

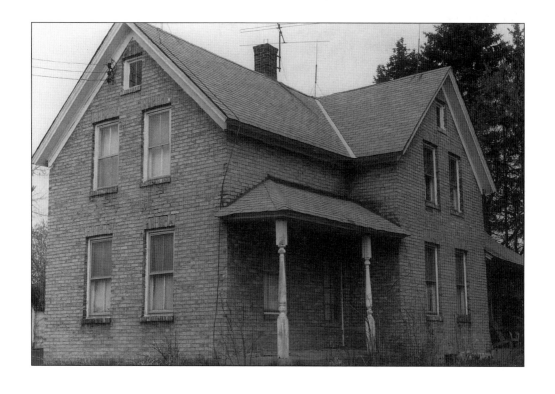

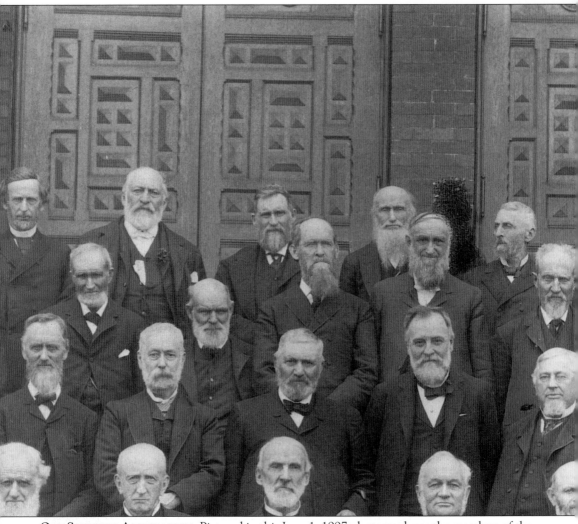

OLD SETTLERS ASSOCIATION. Pictured in this June 1, 1997 photograph are the members of the Old Settlers Association of Minnesota. In February of 1850, with three feet of snow on the ground, Socrates Thompson (third from the left in the back row) and his Indian companion searched for farm land. When Thompson learned the land on the eastern shore of Turtle Lake had already been claimed by Samuel Eaton, Thompson claimed a nearby section. With Thompson's help, Samuel Eaton built the first house on the lake. It was completed in April of 1850, eight years before Minnesota became a state. Mrs. Eaton and their three daughters came to the territory while the Sioux and Chippewa Indians continued to fight. The early settlers were farmers. When he came in 1851, John Ledgergaeber built the first hotel and named it the Half-Way House because it was half way between Saint Paul, Ramsey County and Columbus, Anoka County. The hotel was a stagecoach stop until Ledgergaeber went bankrupt in 1853 and returned to farming. (Courtesy of Minnesota Historical Society)

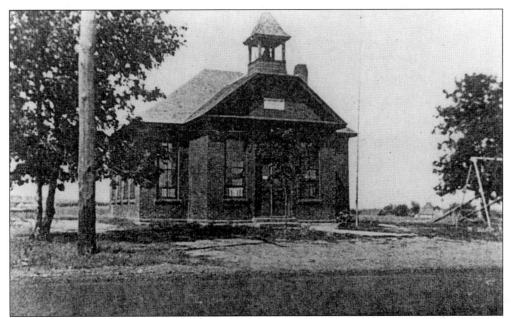

SCHOOL DISTRICT #4 SCHOOL. This school began operation in 1858, when Minnesota became a state. It was known as the District #4 School or the "red" school because it was constructed of red brick. District #4 School was established by the township board to serve the entire township. Lambert, Sonderman, and Marsden were appointed to the District Board of Directors.

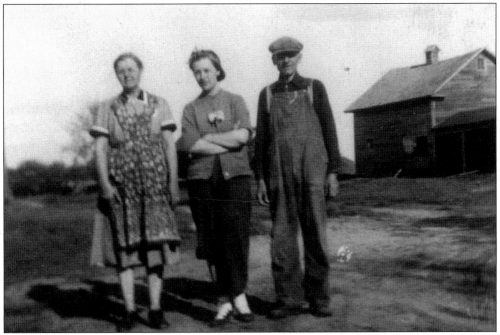

FARM OF CIVIL WAR ERA. This home was built by H.C. Marsden shortly after the Civil War. When Louis and Hilmer Seabloom arrived in the area in 1911, they lived upstairs and kept their livestock downstairs. Annie (Florence) their daughter and Louis Seabloom stood in front of the barn in 1939.

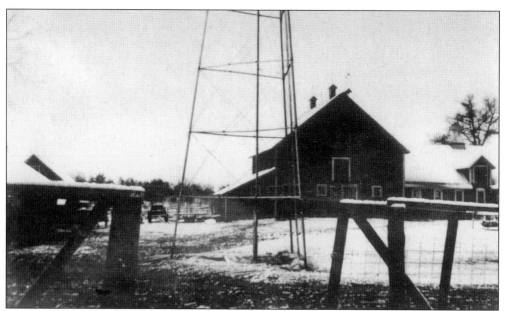

WINDMILL AND BARN ON THE BUCHER FARM. Henry Bucher claimed this farm in 1858, the year Minnesota became a state. In addition to dairy cows, he raised strawberries and potatoes. The Homestead Act of 1862 allowed his son Henry II to homestead property near the Anoka-Ramsey County line and Highway 49 in 1880. A city park commemorates this site.

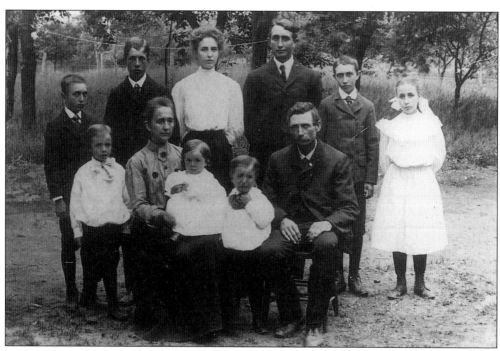

BUCHER FAMILY PICTURE. This is a picture of the Henry Bucher family in 1906. The family is, from left to right: (front row) Carl, Henrietta, Irvine, Ferdinand, and Henry; (back row) Herman, Henry, Anna, Robert, William, and Henrietta.
Note: Ernest, the twin of Irvine, had died.

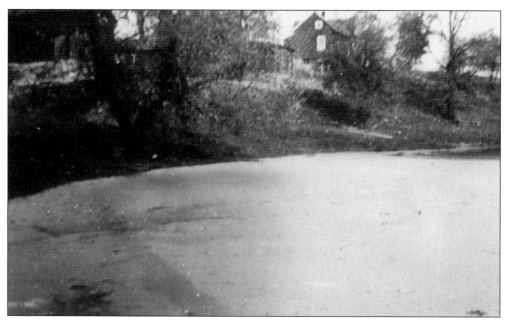

MINNIE LAKE BEHIND KATH HOUSE. Because Shoreview has many low areas, there are numerous drainage ponds. It was common to name the ponds. This pond was behind the Kath home and named Minnie Lake. Many named drainage ponds still exist in Shoreview. When the children were grown, they added an "r," changing the family name to Karth. Current maps label the pond Karth Lake.

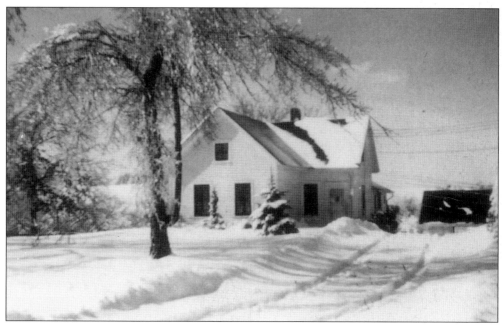

1885 HOME OF KARL AND AMELIA KATH. Karl and Amelia Kath built their home in 1885 on 40 acres of land in the area that is now know as Lexington Avenue and Victoria Street. The Kath's had nine children. When the parents retired, the oldest son rented the farm. After buying the farm from his parents in 1927, Edward Karth raised three children on the homestead.

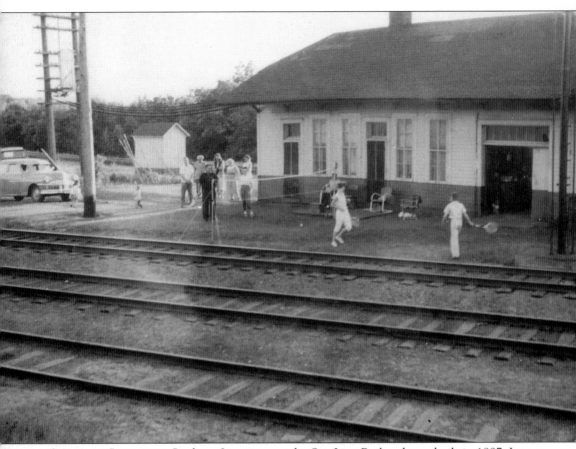

CARDIGAN JUNCTION. Cardigan Junction, on the Soo Line Railroad, was built in 1887. It cost $3700 to build. The south half of the building was the office and the north end was the living quarters for the station agent and his family. The children played badminton at the south end of the building. Cardigan Junction was the switch point for trains running between the Twin Cities and Turtle Lake, Wisconsin. The station had enough track to switch 70 railroad cars. The trains were taken apart and reassembled making new trains bound for either Minneapolis or Saint Paul. Most of the switching was done at night on what they called the "third trick." The station had a green door and was heated by a Duotherm oil stove. In January, the snow blew through the cracks in the wall. There were no modern conveniences. Men and women used separate waiting rooms while they waited for the commuter train to depart or arrive from Saint Paul. The junction building was demolished, but the tracks are still in use.

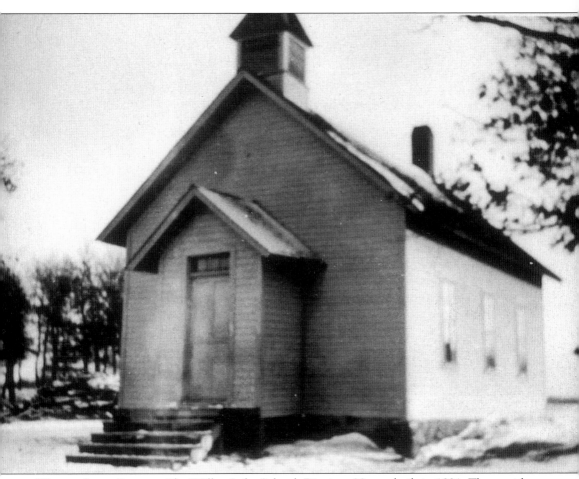

WILBUR LAKE SCHOOL. The Wilbur Lake School, District #28, was built in 1891. The outside of the building was whitewashed. The bell in the cupola was rung to signal the beginning of school and recess. The inside walls had brown tongue and groove wainscot with light green paint on the wall above. The first teacher was Mary Guiney. Someone came in before school started and built a fire in the wood stove that heated the building. There was a metal safety screen around the wood stove to prevent the children from burning themselves. When it was too cold for the children to walk to school, their father would hitch up the horses and take them to school. Bad weather was not an excuse to close the school. There were separate outhouses for the boys and the girls. The children either brought their lunch or went home for lunch. Wilbur Lake School was located on the north shore of what is now known as Lake Shoreview. Its original names were Lake Wilbur or Lake Mud.

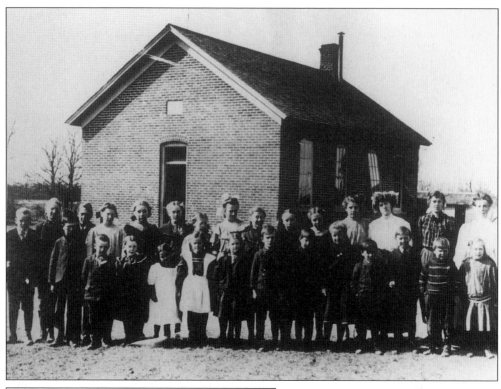

HILL FARM SCHOOL. Hill Farm School, District #25, was a red brick school built by James J. Hill for the children of his employees and the community. It was started to comply with the 1885 State law requiring all children between 8 and 16 to attend school at least 12 weeks a year. The school first appeared on maps in 1886. The people are unidentified.

HILL FARM SCHOOL. A picture was superimposed on a picture of the Hill School, *c.* 1905: (front row) C. H. Schaefer (teacher), Myrtle Erickson, Lydia Morrell, unidentified, Adin Austin, Gertrude Jereczek, Edith Morrell, Ruth Larson, Emil Erickson, and Tina Morrell; (back row) Hazel Austin, Maude Moncrief, Edna Erickson, Mattie Austin, Bessie Erickson, Swan Johnson, and Huldah Morrell.

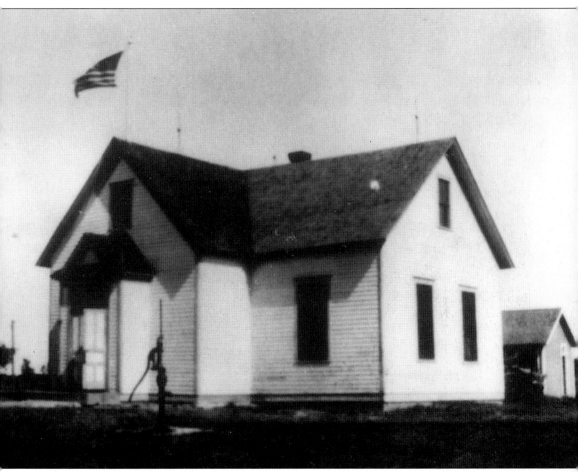

TURTLE LAKE SCHOOL. Turtle Lake School, District #35, was built in 1895 near Turtle Lake. When it opened, there were 20 students in 8 grades. The school had a pump in the front yard and was heated by a wood or coal burning stove in a corner of the room. Sometimes the children brought potatoes and cooked them on the wood stove at lunch. In a single building, a wood shed separated the boys outhouse from the girls outhouse. The school was a center of community activities. The parents sponsored the annual Halloween party and pie socials. The last teacher at the one room school was Ellen Bucher who left in 1950.

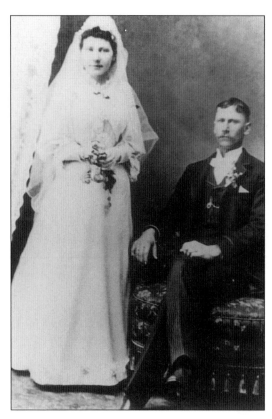

WEDDING PICTURE. This is the formal wedding picture of Anthony Jereczek and Agnes (Hamrick), *c.* 1892. The traditional wedding picture of the time showed the groom seated and the bride standing. The father of Anthony Jereczek spelled the name Joverzick.

1897 PORTRAIT. This 1897 portrait of Louis Seabloom, the father of Hilmer Seabloom, was taken at the time of his marriage to Annie. Louis Seabloom and Ernest Larson were friends and came to the Mounds View Township together from Centerville, Iowa in 1911.

1896 CHASKA BRICK HOME. The Art Larson yellow Chaska-brick home was built in 1896 by August Lepak, who came to America from Germany in 1873. Before Larson's father bought the home in 1935, it was owned by C. Peterson. As a young man, Art Larson held several jobs. He was a streetcar motorman, drove a Ford Model T truck delivering coal, and worked for the telephone company.

BARN AND PUMP HOUSE. This was the barn, pump house, and machine shed on the Art Larson farm. The buildings were wired for electricity in 1925. The machine shed was an essential for the farmer. Even before the advent of mechanized farming, they had to store the wagons, buggies, plows, and mowers. The present address is 1170 W. County Road I.

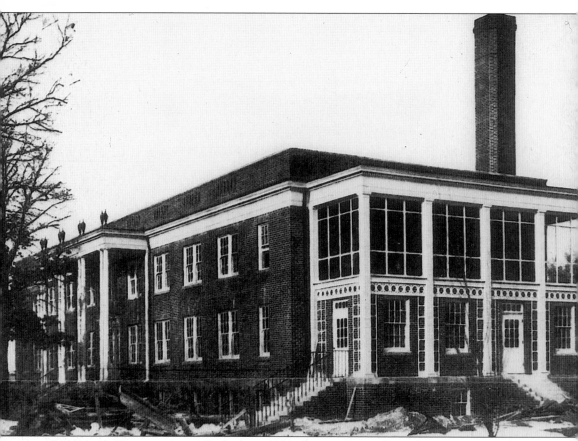

CHILDREN'S PREVENTORIUM. Built about 1900, Cuenca Hospital at 210 N. Owasso Blvd was a tuberculosis sanitarium. In 1910, it was purchased by the Anti-tuberculosis Association. In 1915, Dr. Henry Longstreet Taylor convinced the association to change its function to a preventorium for children who had been exposed to tuberculosis. During the first 14 months of operation, they cared for 85 children of parents with tuberculosis. The length of a child's stay could be a few weeks or as long as several years. The children lived in dormitories and attended their own two room school. The preventorium was closed in 1953 and leased to the State of Minnesota for $1 a year and reopened, in 1955, as an annex to Faribault State Hospital with the name of Lake Owasso Children's Home. In 1992, while working in the building, a worker discovered a ledger listing the names of all the children who had stayed at the preventorium.

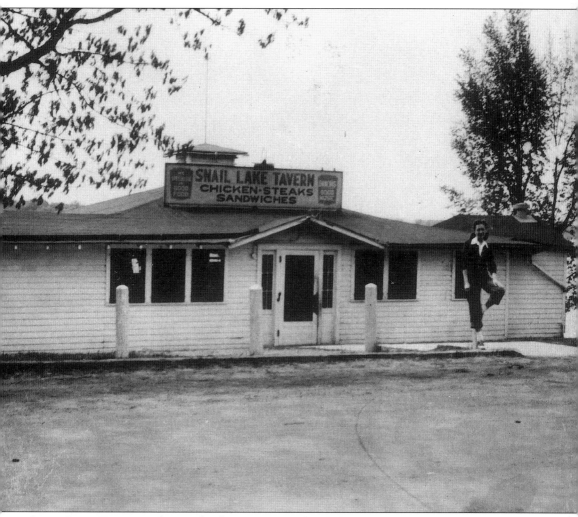

SNAIL LAKE TAVERN. The Snail Lake Tavern was founded in the early 1900s on the route of the Mounds View Pony Express. A tiny grocery store adjacent to the club served "men of means" who came to nearby resorts to hunt and fish. In the 1930s, the club was frequented by renowned Chicago area gangsters. Customers recognized Al Capone, Ma Barker, John Dillinger, and Baby Face Nelson from their pictures in the newspaper. When prohibition ended, the tavern served "set-ups:" beer and lots of food. They had punch boards and a pinball machine. From 1966 to 1988, the tavern was owned by Al and Gloria Buetow. They changed the name to the Snail Lake Club. A three-piece band played for dancing. The club served the community as an old time dance hall and the location of wedding and other receptions. Frances Springer, a teacher, operated the "bottle club" into the 1950s. The building was demolished in 1988.

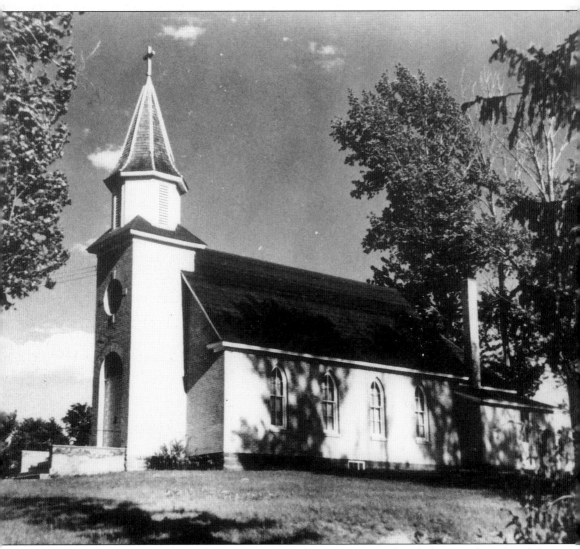

BETHANY CHURCH. Bethany Swedish Evangelical Lutheran Church began when Swedish settlers living near the Hill Farm gathered for worship, in 1900. The church was formally organized Christmas Day 1903. The first services were preached by the Rev. Carol O. Swan. Parishioners built their first church in 1911 with donated land, materials, and labor. The services were in Swedish until 1919 when they began alternating between Swedish and English. The Mounds View English Lutheran Church evolved from a Baptist congregation. Their early services were held at the James J. Hill School. The story is told that they had to chase the pigs from a nearby pig farm out of the parking lot to go home. Mounds View English Lutheran became Apostles' Lutheran. In 1962, Bethany Lutheran and Apostles' Lutheran consolidated to become Incarnation Lutheran Church.

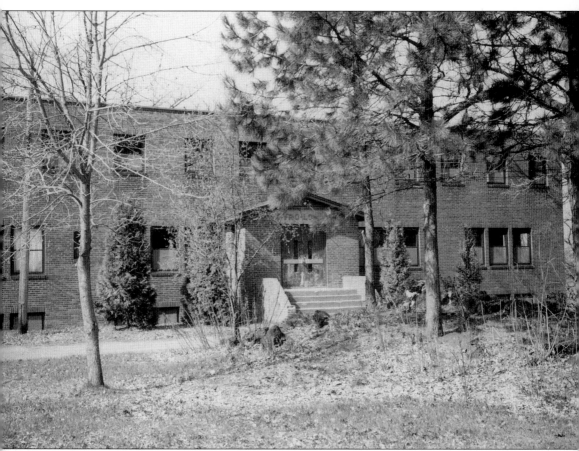

UNION GOSPEL MISSION. Union Gospel Mission of Saint Paul was organized December 1, 1902, with Rev. MacKinney as superintendent. The mission began serving women and children in the 1920s. This building was the Gyro Lodge of the Union Gospel Mission in Shoreview. In 1930, Peter MacFarlane stumbled on property on Lake Maryland, now Snail Lake, that was a dance hall and road house run by Ma Barker. Two weeks after prayer, they learned the land could be bought for delinquent taxes. They had found a site suitable to build their camp for "at-risk" boys. The bricks for the building were bought for $150. Men living at the Mission built it with a donated $1000, donated lumber, and material salvaged from demolished buildings. The boys paid $1 for a week at the camp. In the summer of 2001, a new building will be completed and ready for campers.

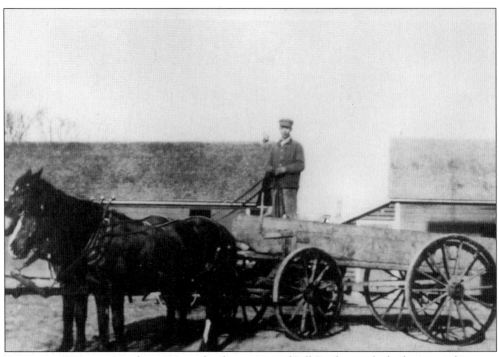

TEAM AND WAGON. No date is given for this picture of Bill Bucher with the horses and wagon. Bill was the son of Henry Bucher Sr. The team of horses and wagon had many purposes including the transporting of produce to the Farmers Market in Saint Paul.

FARMERS MARKET. Henry Bucher raised the strawberries that he sold at the Saint Paul farmers' market. These strawberries were ready for the trip to the market. The farmer began his journey about four in the morning to make the four-hour trip to the market. Trucks later replaced the horse and wagon as the means of transporting the produce to the Farmers Market.

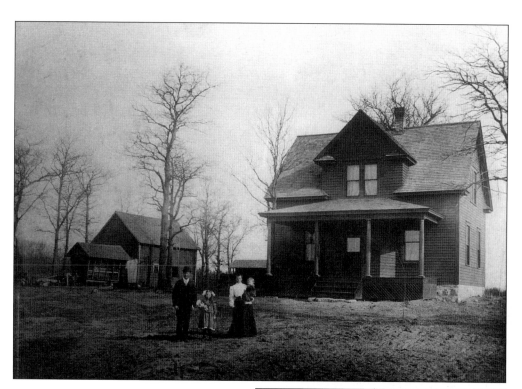

ERNEST LARSON FARM. The Larson family stood in front of their home and barn. As did all the farms, there was a pump in the front yard. Augusta and Ernest Larson, Ernest's parents, immigrated from Sweden to Centerville, Iowa and to Mounds View Township in 1902 with the Seabloom family. This farm was on the north side of County Road I.

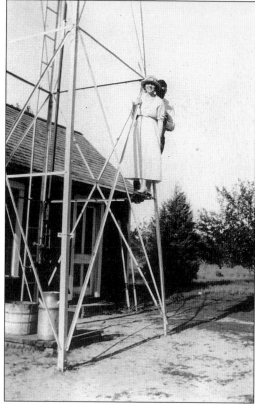

WINDMILL. This windmill and pump house were on the Ernest Larson farm. Windmills were the only means of pumping water and were often climbed. People standing on the windmill were not identified.

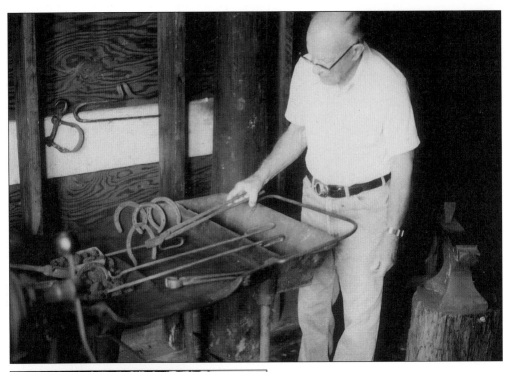

BLACKSMITH. Many of the farmers were also blacksmiths. Carl Holmberg is shown standing by a 1903 Forge. Because the horse was the primary means of transportation, horseshoes were the most common blacksmith service needed by the farmer.

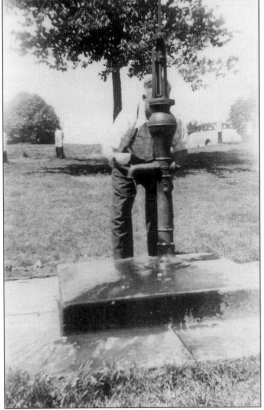

PUMP IN THE YARD. Everyone had a pump in the front yard. A dipper hung from the pump and when someone wanted a drink they simply used it and hung it back on the holder.

SURVEY FROM 1856. Original survey by Issac N. Higbee, in 1847, was certified by Dana E. King on April 28, 1875.

3	Certified Copies of Original Surveys of Ramsey County	Filed in Original Town Plats (Laws of 1856, Chap. 13)
	T. 30, R. 23, surveyed in 1847 by Issac N. Higbee, Deputy Surveyor. Certified as a true copy of Original plat in this office. April 23, 1875 Dana E. King, Surveyor General.	
4	Dana E. King, Surveyor General to The Public	Certificate Dated April 28, 1875 (for T. 30, R. 22) Dated April 30, 1875 (for other towns)
	That foregoing lists accurately describe all corners and land in Town- ships named as appears in original and approved field notes on file in this office.	
5	Original Entry by Edmund Rice	Entered Sept. 5, 1851 SE¼ of NE¼, and Lot 4, Sec. 14, T. 30, R. 23.
6	The United States to Edmund Rice	Patent Issued Aug. 2, 1852 Filed Sept. 4, 1890 "262" Deeds 124
	SE¼ of NE¼, and Lot 4, Sec. 14, T. 30, R. 23. Act of Feb. 11, 1847. Warrant #73627.	
7	Lewis A. Groff, Commissioner of the General Land Office to The Public	Certificate Dated July 26, 1890 Filed Sept. 4, 1890 "262" Deeds 125 That annexed copy of Patent in
	favor of Edmund Rice founded on Warrant location No. 73627, for 160 acres, Act of 1847 is a true and literal exemplification from the record in this office.	
8	Edmund Rice to Socrates A. Thompson	Bond for Deed Dated Sept. 5, 1851 Ack'd Nov. 28, 1851 Filed Nov. 29, 1851 "A" Bonds 144 $800.00
	SE¼ of NE¼, and Lot 4, Sec. 14, T. 30, R. 23.	
9	Edmund Rice and Anna M., his wife to Anson A. Brewster	Warranty Deed Dated Jan. 9, 1853 Filed Feb. 8, 1853 "E" Deeds 227 SE¼ of NE¼, and Lot 4, Sec. 14, T. 30, R. 23.
10	Anson A. Brewster, (Signs A.A.) and Sarah P., his wife to Socrates A. Thompson	Warranty Deed Dated June 12, 1858 Filed July 21, 1858 "T" Deeds 503 SE¼ of NE¼, and Lot 4, Sec. 14,

11	Socrates A. Thompson, and Angeline, his wife to William Bishop	Mortgage Dated July 21, 1858 Filed Aug. 18, 1858 "N" Mtges. 484 $200.00
	SE¼ of NE¼, and Lot 4, Sec. 14, T. 30, R. 23.	
12	Socrates A. Thompson and Angeline, his wife to Jeremiah W. Selby	Mortgage Dated July 21, 1858 Filed March 1, 1859 "O" Mtges. 453 $250.00
	SE¼ of NE¼, and Lot 4, Sec. 14, T. 30, R. 23. Subject to a mortgage dated July 21, 1858 to William Bishop, for $	
13	J. W. Selby to Socrates A. Thompson, and wife	Marginal Satisfaction of "O" Mtges. 453 Dated Sept. 15, 1862
14	Socrates A. Thompson and Angeline, his wife to William Bishop	Warranty Deed Dated Aug. 19, 1862 Filed May 18, 1864 "DD" Deeds 523 SE¼ of NE¼, and Lot 4, Sec. T. 30, R. 23.
15	William Bishop and Emma B. (Signs Emma), his wife to Paul Jerreszeck	Warranty Deed Dated Aug. 16, 1870 Filed Aug. 29, 1870 "VV" Deeds 470 SE¼ of NE¼, and Lot 4, all
	T. 30, R. 23, Sec. 14, situated in Mound View Township, containing 73 acres, more or less.	
16	S. Lee Davis, Auditor of Ramsey County, by Deputy to State of Minnesota	Certificate of Tax Sale Dated Dec. 18, 1874 Filed June 9, 1877 "67" Deeds 55 Judgment Nov. 16, 1874 Sold Dec. 18, 1874.
	Lot 4, Section 14, T. 30, R. 23.	
17	S. Lee Davis, Auditor of Ramsey County to The State of Minnesota	Certificate of Tax Sale Dated Dec. 18, 1874 Filed Feb. 14, 1877 "67" Deeds 126 Judgment Nov. 16, 1874. Sold Dec. 18, 1874. $3.99
	Lot 4, Section 14, T. 30, R. 23. Given to correct error in former certificate, etc.	
18	S. Lee Davis, Auditor of Ramsey County, by Deputy to Herman Greve	State Assignment Certificate Dated Nov. 28, 1876 Filed Jan. 9, 1877 "B" Assgts. 35 Judgment Nov. 16, 1874. So Dec. 18, 1874, $13.52.
	Lot 4, Section 14, T. 30, R. 23.	

SOCRATES THOMPSON ABSTRACT. This was the abstract for the Socrates Thompson property. The mortgage was dated July 21, 1858, for the amount of $200.

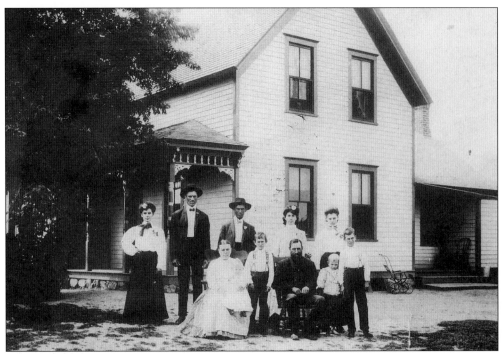

KURKOWSKI HOME. This 1905 Kurkowski home was typical of the farm homes in the early 1900s. They were heated with wood and in the kitchen there was a large wood burning stove with a water well. Pictured here are: (front row) Grandma, Lena, George, Grandpa, Andrew, and Nick; (back row) Veronica, Frank, Joe, Victoria, and Cecelia. Victoria became the wife of the first mayor, Ken Hanold.

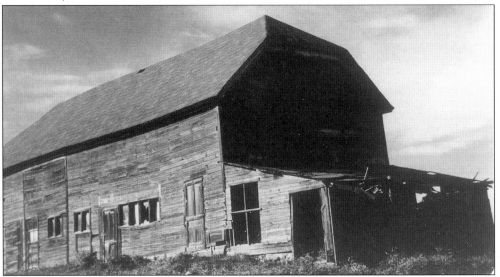

ANDREW KURKOWSKI BARN. After the Kurkowski barn was no longer needed as a barn it served several roles in Shoreview's history. It was the original site of the Linder's Fabricating and Manufacturing Company which moved to the new Industrial Park in 1962. The land is now owned by the Asphalt Specialties Company. The Asphalt Specialties Company provided the asphalt to pave the local roads beginning in 1928.

CHILDREN. The father and children posing with one of the farm animals were not identified. Boys of that era wore knickers, and everyone wore a hat.

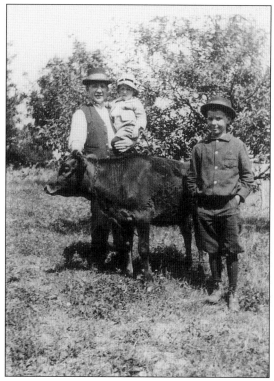

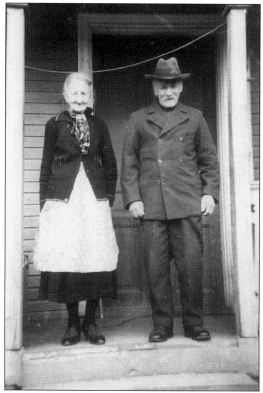

ELDERLY COUPLE. The way they were dressed was almost a uniform of the era. Women usually wore an apron and the men wore a suit typical of the Civil War era, and always a hat.

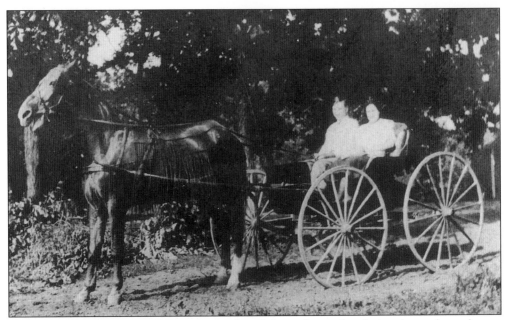

HORSE AND BUGGY. In 1910, Tony Jereczek and Agnes Jereczek rode in a horse drawn buggy. The ox cart, horse and buggy, stage coach, and the commuter train from Cardigan Junction were the means of transportation until cars began to make their appearance about 1910.

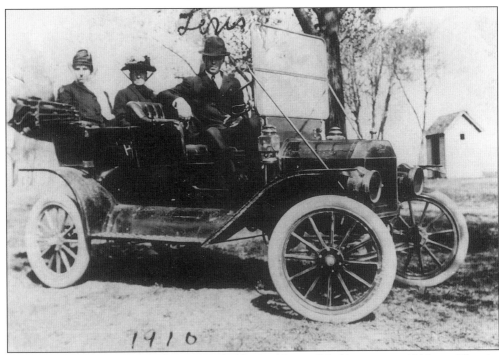

CAR IN 1910. Pauline Jereczek, Anna Schifsky, and Louis Schifsky are in a 1910 car. The ties kept Anna's hat from blowing off in the open car. The farmers began replacing the horse and buggy with cars around 1910. The square lanterns near the windshield provided light while driving after dark.

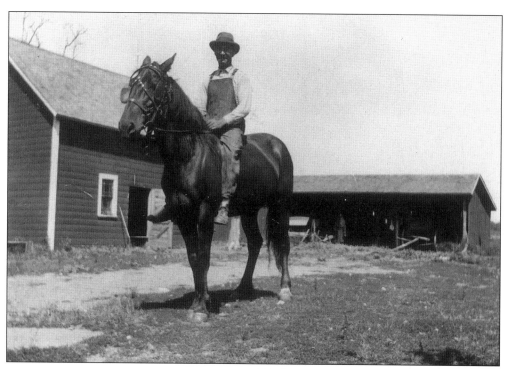

MAN ON A HORSE. Horseback was a common means of transportation. Having horses was essential to get from place to place and do the chores on the farm.

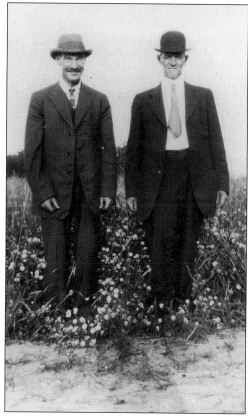

TWO PROSPEROUS MEN. Two unidentified men stood by the side of the road. They wore suits of the era and the hat that all men considered essential.

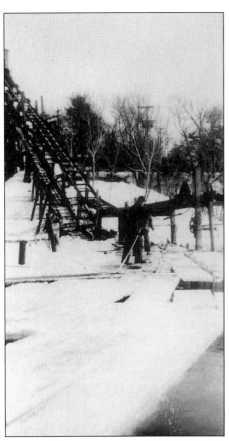

PEOPLES ICE AND COAL COMPANY. The building of the Peoples Ice and Coal Company was yellow and rose five stories above the lake. Most of the crew were local farmers. The harvest began when the ice was about 36 inches deep which usually occurred the day after New Years Day. The men scraped snow, cut the ice on the eastern shore of Lake Owasso with large circular saws then switched it into the building and covered it with sawdust.

ICE HARVEST. The men stood in front of the ice chute. The chute used a chain to bring the 450–500 pound ice blocks to the yellow 5-story building where the ice was stored. Foreman O'Lear and David Guerin stood with their group. The other men were not identified. Courtesy of Little Canada Historical Society.

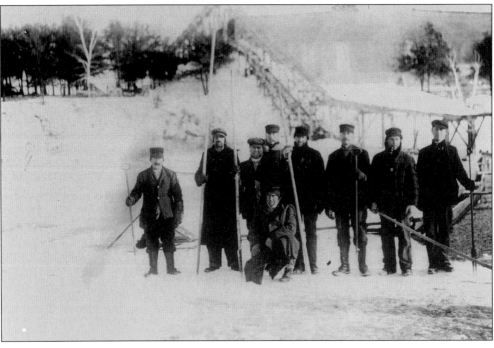

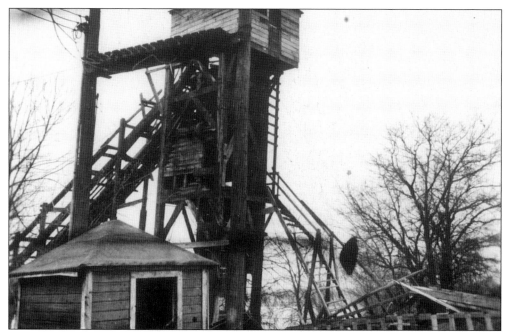

ICE HARVEST. The ice was marked into 18 by 24 inch squares and then cut into huge blocks weighing from 450–500 pounds each. Over 100 men worked the ice harvest. The blocks of ice became rafts in the water. The men used crampons to start the blocks of ice up the chain mechanism that brought them out of the water and up into the building.

ICE SLED. No date is given for this picture. Farmers cut ice in the winter and stored it in sheds on the farm. Straw and sawdust were packed around the ice to prevent it from melting . Many farmers worked for the Peoples Ice and Coal Company during the six weeks a year that ice was cut on Lake Owasso. Refrigerators did not come into the area until after World War II.

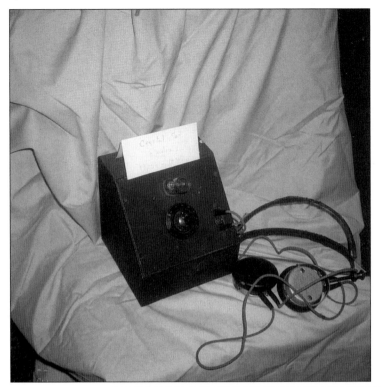

CRYSTAL SET, 1910.
Some of the men who worked on the ice harvest used a crystal set radio with headphones like this one. They used the crystal set with headphones much as people now use a "Walkman." (Courtesy of Little Canada Historical Society)

CLAMP ON SKATES. Clamp on skates were clamped onto the sole of the boot. They came in all sizes. These appear to be adults skates. Both children and adults enjoyed skating on the many lakes in the area. Another popular skate was the long straight bladed speed skate. (Courtesy of Little Canada Historical Society.)

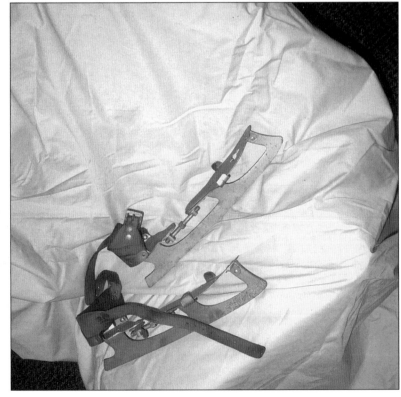

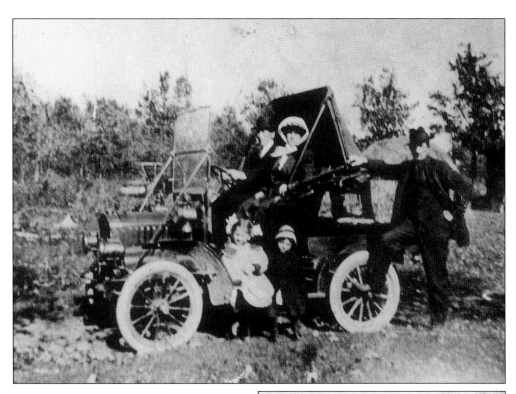

LUNDBERG CAR. Sven and Charlotte Lundberg sat in the car, and Art Lundberg stood next to the car. Charlotte and Harold Lundberg sat on the running board. This road, consisting of dirt tracks, was typical of the roads in the early years of cars.

1910 MODEL T. Frank Schifsky, Louis Schifsky, Pauline Jereczek, and Dora Auge ready to leave in a 1919 Model T. The ladies had to secure their hats because the car was open. The tank on the running board contained a mixture to fuel the lanterns by the windshield.

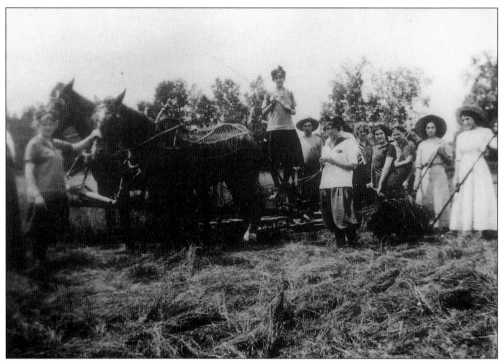

HAYING IN 1910. Several women used a team of horses to help with the haying. Gert and Pauline (Lena) Jereczek on the right of the picture held pitch forks. Because farming was a family affair, the crew often included extended family members. The names of the others are unknown.

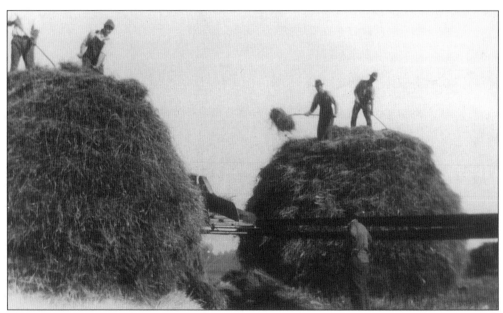

SWEDISH HAYSTACKS. When making a Swedish Hay Stack, it was said that they were building the stack. A Swedish haystack was round and tapered. The men carefully placed each pitch fork of hay next to the previous one in a circular pattern. The round shape made for a better quality of hay because it prevented moisture penetration.

Two

1911–1940

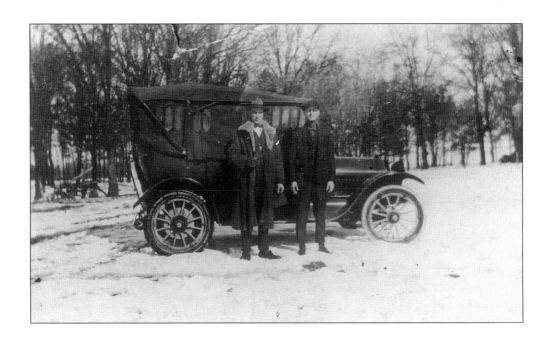

EARLY CAR. Cars were becoming popular. The car was replacing the horse and buggy for non farming transportation.

FIRST CAR. Art Larson stood beside his first car.

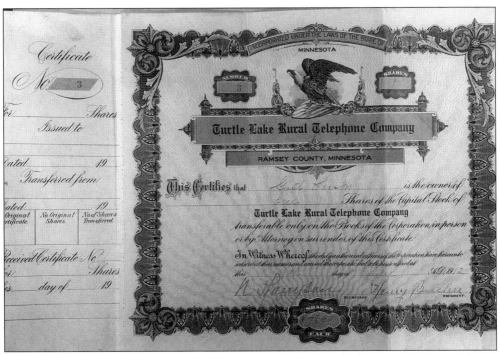

TURTLE LAKE RURAL TELEPHONE. This Turtle Lake Rural Telephone Company certificate, Number 3, was sold to Gust Larson for the price of $78.40 on June 11, 1912. The president of the company was Henry Bucher. Victoria Sina was listed on the 1910 census as being a telephone operator.

SCHIFSKY, SINA FAMILY. Anna Schifsky stood in front of her home. Dorothy Sina (Schifsky) was born in the upstairs back bedroom of the home on February 16, 1916.

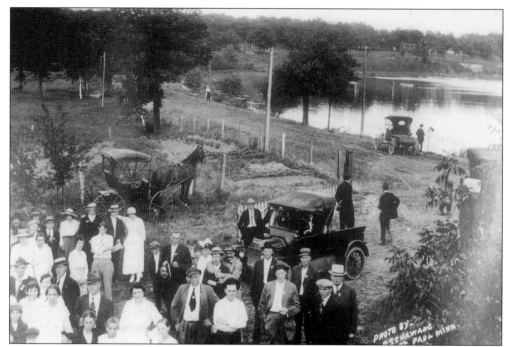

LOCAL MILK PRODUCERS PICNIC. The Second Annual Picnic of the Local Milk Producers Association was in 1917. Milk was sold locally or taken into St. Paul to be processed. The picnic was held on a strip of land between Lake Wabasso and Lake Owasso. At the time of the picnic, transportation was in transition. In the picture, several means of transportation can be seen; a horse and buggy, cars, and a truck.

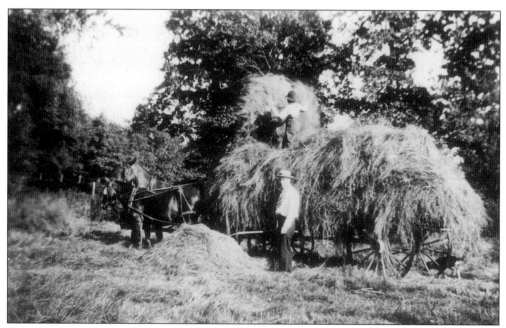

HAY WAGON. The haying crew put the last of the hay on the wagon before either stacking it or placing it in the barn for winter feed.

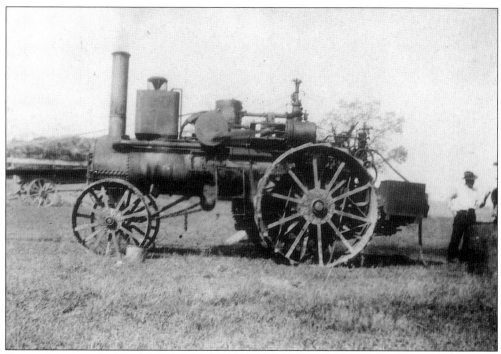

STEAM THRESHER. No date is available for this picture. This steam thresher was on the Fabianski farm. The thresher was an expensive piece of farm machinery and used only once a year at harvest time. The threshing crew would travel from farm to farm harvesting the crops until the harvest was completed.

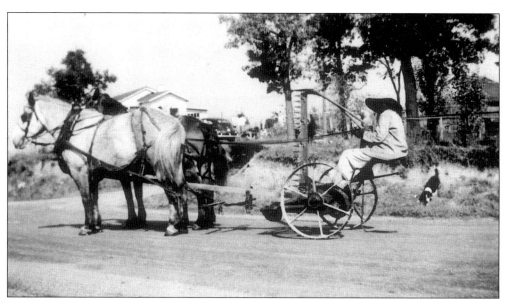

TEAM AND MOWER. Victoria Fabianski was ready to go to the fields to mow with a Tag mower. Tag mowers had a ground driven sickle. Gravel roads were considered good roads. Farm people usually wore a hat to protect themselves from the sun.

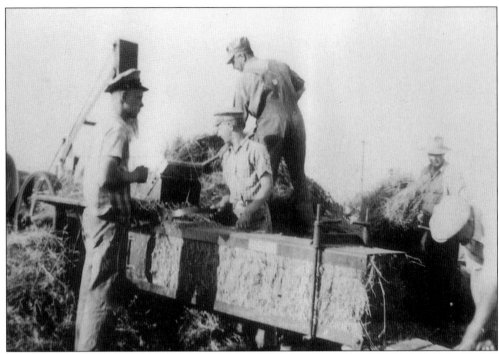

BALING HAY. Everyone worked when it was time to bring in the hay. The hay wagon was piled high with hay and pulled by a team of horses.

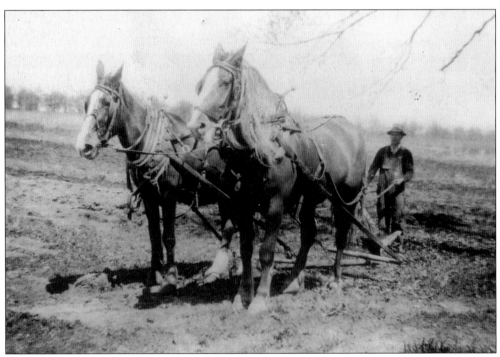

TEAM AND WALK BEHIND PLOW. The team and plow were essential to preparing the field for planting.

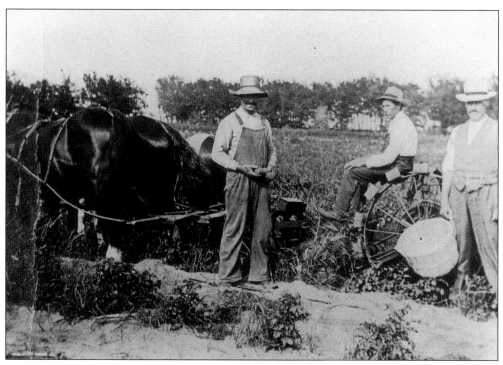

THREE MEN DIGGING POTATOES.
The men dug potatoes and put them in bushel baskets. The soil was well suited for the growing of potatoes. Potatoes were a common crop.

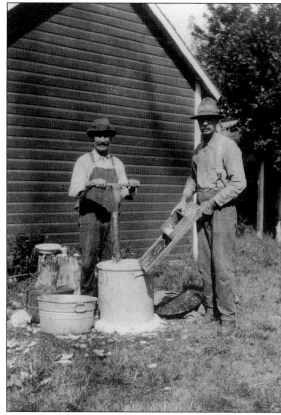

MAKING SAUERKRAUT.
The men grated cabbage. They were preparing to make sauerkraut in the ceramic crocks.

TYPICAL HOME. This was a typical home of the 1920s.

KINBERGER BARN. The barn was usually the first building built on the farm. This barn on the Joseph Kinberger farm was one of several styles of barns in Shoreview.

44

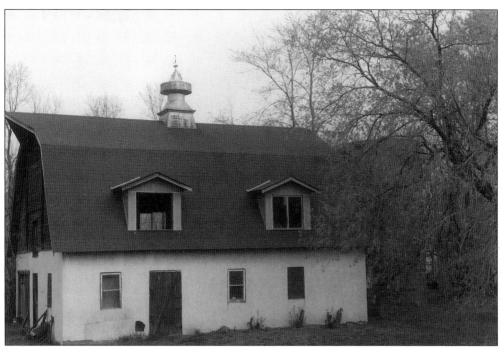

DOMBROWSKI BARN. This barn was on the Dombrowski Farm. A barn with a cupola and windows on the second floor was one of several styles of barns in the Shoreview area.

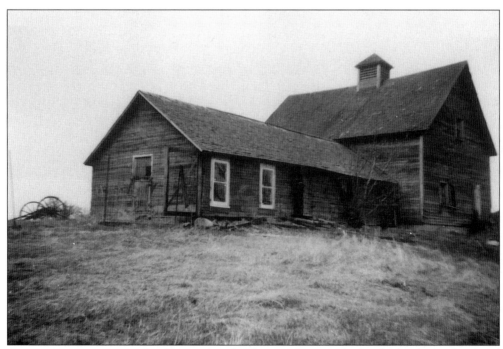

OUT BUILDINGS ON THE BYE FARM. Another barn with a cupola that had only one level and was smaller than the typical barn. Several of the teachers at the Wilbur Lake School boarded with Bill Bye family.

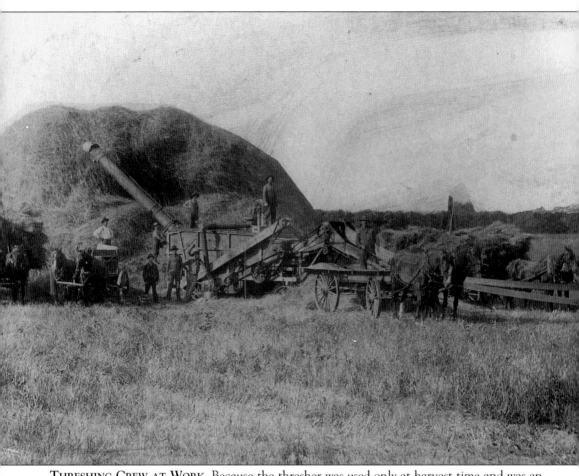

THRESHING CREW AT WORK. Because the thresher was used only at harvest time and was an expensive piece of machinery, the cost was shared. The threshing crew went from farm to farm

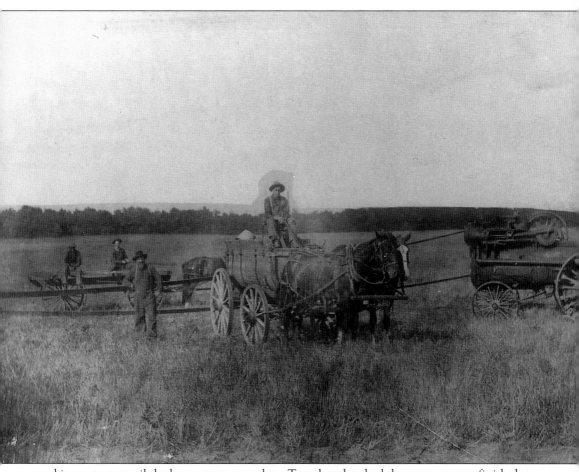

working as team until the harvest was complete. Together they had the manpower to finish the harvest at all of the farms within the limited time available.

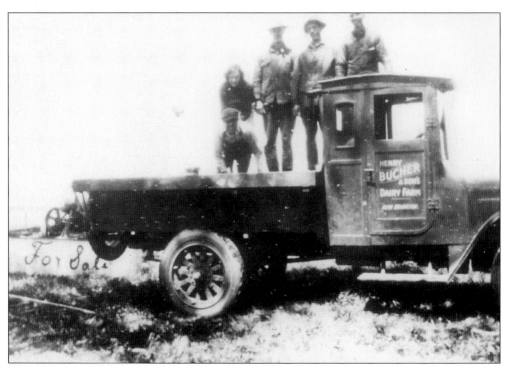

BUCHER DAIRY TRUCK. The people standing on the Henry Bucher & Son's Dairy Farm truck were not named. No date is available for this picture.

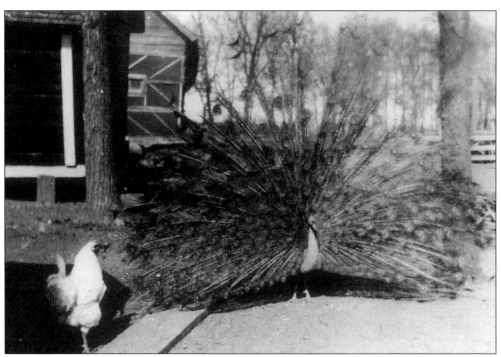

PEACOCKS. In the 1920s, John (Jereczek)Rickey raised blue peacocks as a hobby. This was one of his birds with its fan displayed.

PICTURE OF A CHILD. The child pictured is Ken Fabianski. Both girls and boys wore dresses and had long hair.

PICTURE OF A CHILD. In formal pictures of children during that era, it was difficult to determine if the child was a boy or a girl.

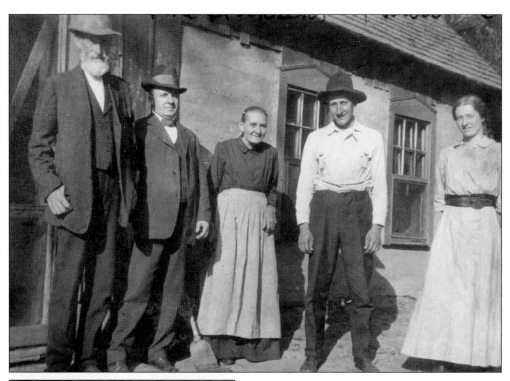

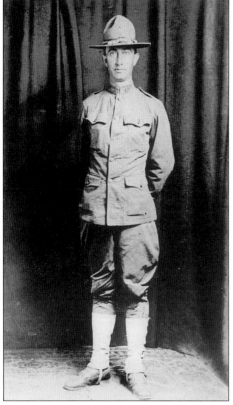

HANSON FAMILY. This picture of the Hanson Family of Turtle Lake was taken in 1917. Their original house on Turtle Lake was made of logs. The road leading up to their home was named Hanson Road.

WILLIAM BUCHER. William Bucher posed in his World War I Army uniform.

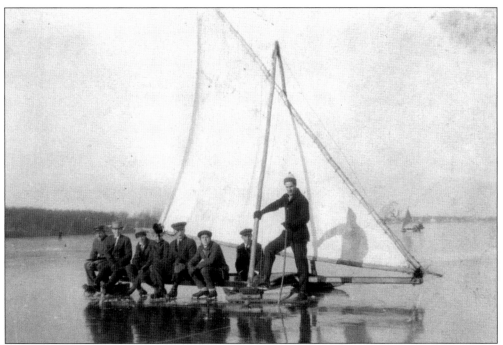

ICE BOAT. Ice boats were popular in the area. This picture was taken in 1918. It was said that some of the local ice boats could travel as fast as 70 miles an hour. The first five individuals were unidentified, the last three people on the boat were Louis Schifsky, Tony Moga, and John Moga.

KUEHNE FARM. This was the Kuehne Farm looking from the south. Like most of the farms of the era there was a home, barn, a windmill, and large chicken coop.

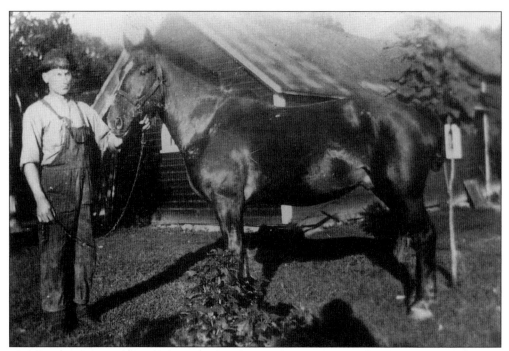

HORSE AND BARN. John Rickey stood in his yard near the barn holding a horse. He had changed his name to Rickey from Jereczek. Rickey was his nickname until he decided to make it his surname.

HOME ON TURTLE LAKE. This was the home of John (Jereczek)Rickey on Turtle Lake. The site is now occupied by Turtle Lake County Beach.

1920s ROAD. The road to the homes and farms were usually dirt paths like this one on the Carl Holmberg farm. In the 1920s, this was considered to be a good road.

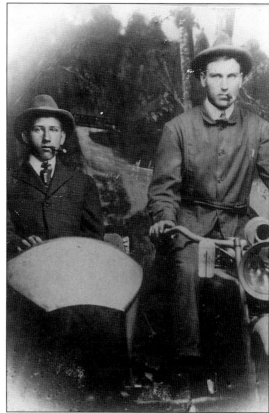

1920s MOTORCYCLE. John (Jereczek) Rickey and his brother Valentine Jereczek rode a 1920s motorcycle.

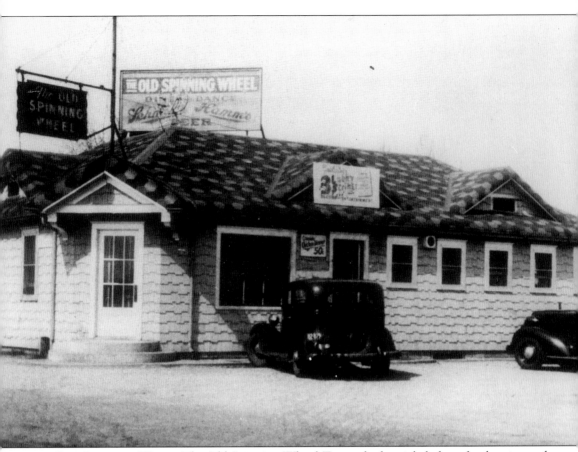

OLD SPINNING WHEEL. The Old Spinning Wheel Tavern had a nickelodeon for dancing and operated as a nightclub and dance hall between 1928 and 1942. The story is told that when there were two teachers at the Snail Lake School across the street, they sometimes went over to the Spinning Wheel at recess and danced to the nickelodeon. After the Old Spinning Wheel closed, Zecks Market opened on the site.

STYLES FROM THE 1920s. John and Amelia (Jereczek) Rickey dressed up after their wedding in the 1920s. When a person of that era was dressed up, it was said that they were "dressed to kill."

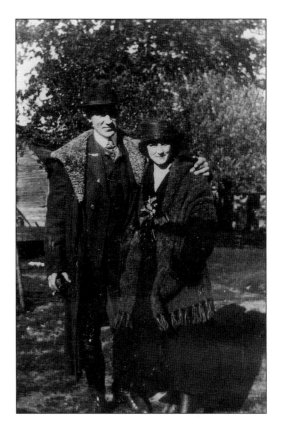

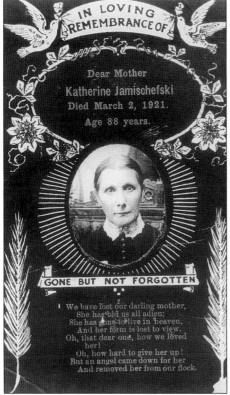

REMEMBRANCE CARD. This was the remembrance card of Katherine Jamischefski who was born in 1833 and died March 2, 1921, at the age of 88.

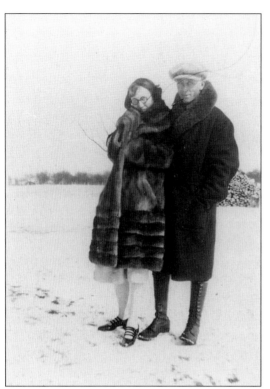

STYLES FROM THE 1920S The picture shows Gladys and Hilmer Seabloom as they dressed in the 1920s. Gladys and Hilmer met while they skated on Turtle Lake.

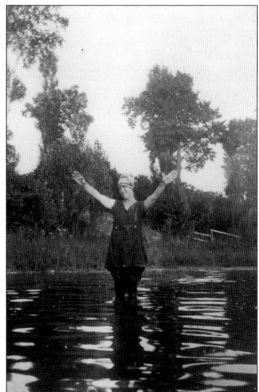

1920S SWIMMING SUIT. Karen Holmberg stood in Snail Lake and posed in her swim suit.

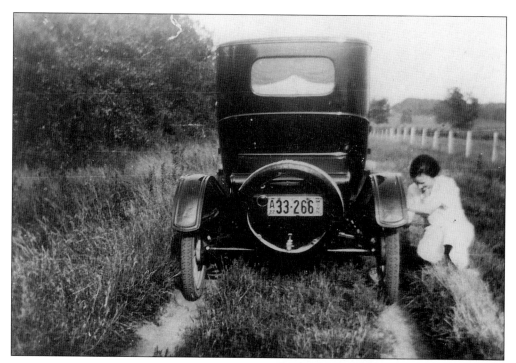

WOMAN CHANGING A TIRE. The picture shows Amelia Rickey changing a tire on her car. The road was typical of the early 1920s. Roads often consisted of two ruts with grass on either side and between the tires.

CLEANING FISH. John (Jereczek) Rickey cleaned a Northern in front of his Turtle Lake home. The name of the child is unknown.

GAS STATION. This was the first gas station in the area that became Shoreview. It was the original station belonging to David Guerin, but does not resemble later stations. The shed was put up in 1926 and held 2 50-gallon drums of gasoline with pumps on top of them. When in use the front was propped up with posts.

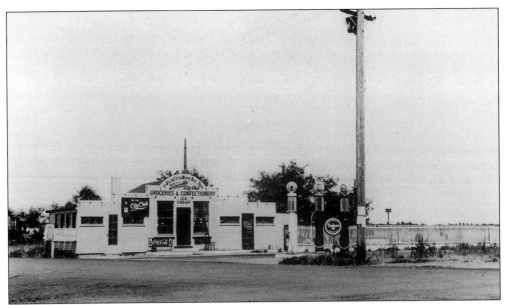

DAVE GUERIN'S TEXACO. The Guerin Gas Station was the first in the area. He built it in 1928. His son Roy worked there while a teenager and later for $1 a day. He told of delivering 50-gallon drums of gasoline to the Dillinger Cottage, near Lake Vadnais, and receiving a $10 or $20 tip. Roy met his wife at the station when she "stopped in for gas with another fella."

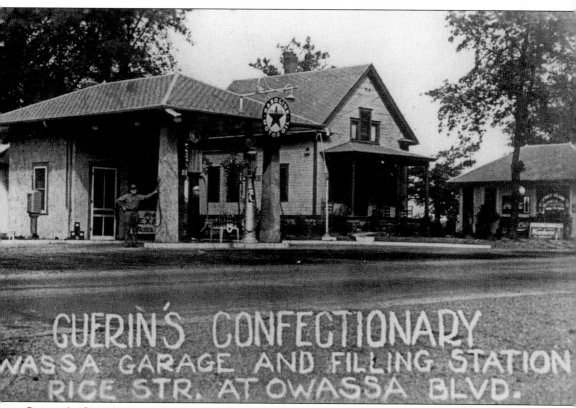

GUERIN'S CONFECTIONARY. Roy Guerin and his wife Anne took over the business from his father, David, in 1938. In addition to the gas station, Guerin's had a grocery and confectionery store. The family lived next door. When he went next door to have lunch, the young children would watch for customers and signal him that his help was needed by rapping on a pipe between the house and store. The business was at 3855 N. Rice Street. Long time customers were called by name and were "on the books" creating a charge system before charge cards were used.

1921 STAR. John (Jereczek) Rickey and wife sat on the running board of the 1921 Star. The children in front of the car were unidentified.

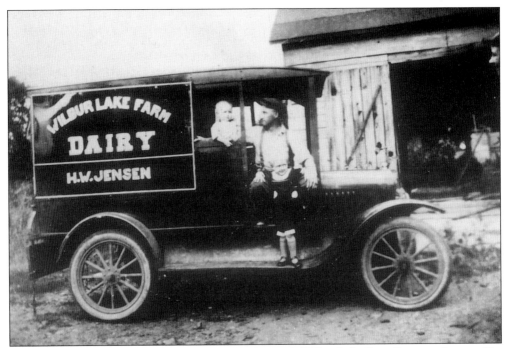

1923 WILBUR LAKE DAIRY TRUCK. Pictured is the 1923 Wilbur Lake Farm Dairy truck owned by H. W. Jensen. Jim, Henry Jensen's son, stood next to him and Mabel stood on the running board.

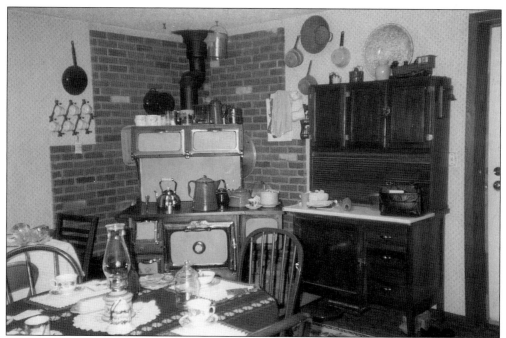

KITCHEN WITH A WOOD STOVE. When Verlie Miller was a child, this stove was in the kitchen of her home. She has reconstructed this old time kitchen in the lower level of her home and uses the wood burning stove with a water well on special occasions.

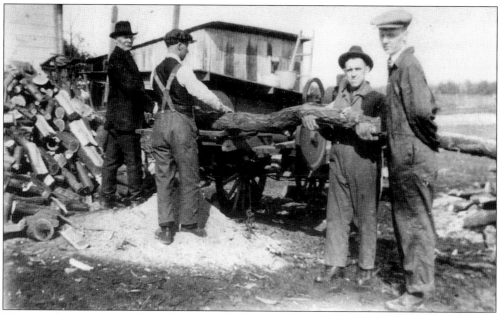

MAKING WOOD ON THE FARM. Because the homes were heated with wood stoves, cutting the wood and preparing it to be burned was an essential activity in the 1920s. The term was "making wood" rather than cutting wood. Karl Kath (his son's changed family name to Karth), son Frank Karth, a relative Charlie Neuenfeldt, and son Ed Karth made wood for the winter on Frank's farm.

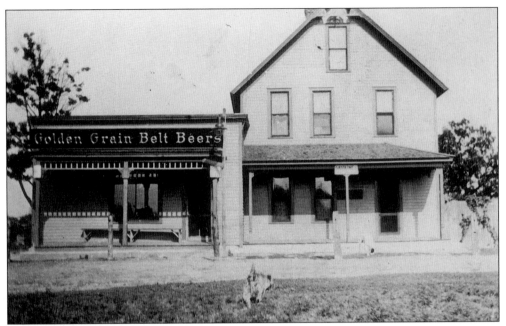

NICK THOMPSON HOME. Pictured is the Nick Thompson home and store. There were several stores similar to this one in Shoreview.

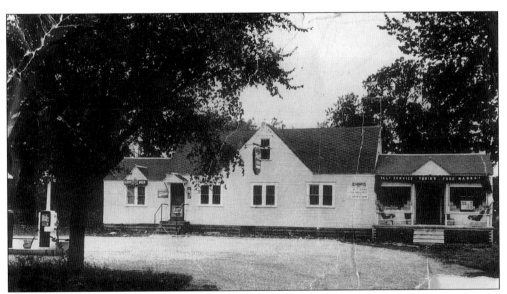

TOBIN'S. Peter Tobin's place of business consisted of a saloon, dance hall, gas pumps, and a small grocery store. In the 1950s it was remodeled and renamed the Sandpiper Supper Club.

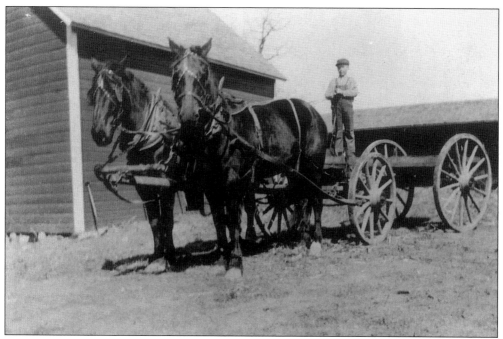

TEAM WITH FLATBED WAGON. The team and flatbed wagon were essential for doing the farm chores.

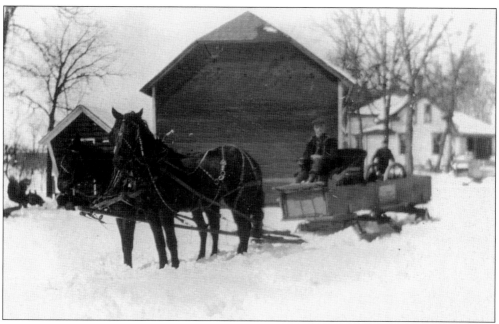

TEAM AND SLEIGH. A team and work sleigh ready for work waited beside the Jereczek barn. Cars were becoming popular. However, in the winter it was a definite advantage to have a horse and sleigh.

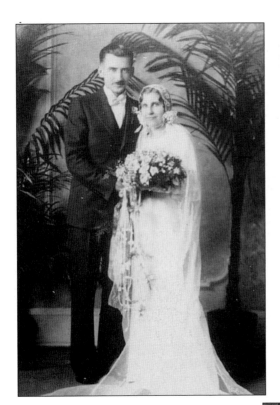

1920s WEDDING. Clara Dombrouski, who was born in 1899, was married to Lawrence Kielb in the 1920s. They are pictured after their wedding.

1927 WEDDING. Gladys (Zschiesche) and Hilmer Seabloom were married in the parlor of the home at 290 Virginia Avenue in Saint Paul on June 30, 1927. They stood beneath a white arbor decorated with freshly picked wild flowers. Their farm was located at the site now known as Lexington Avenue and Robinhood Place.

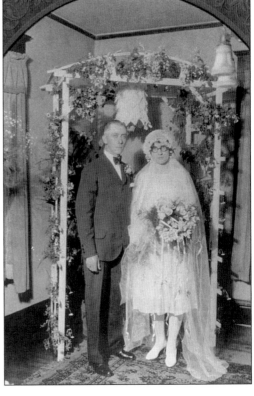

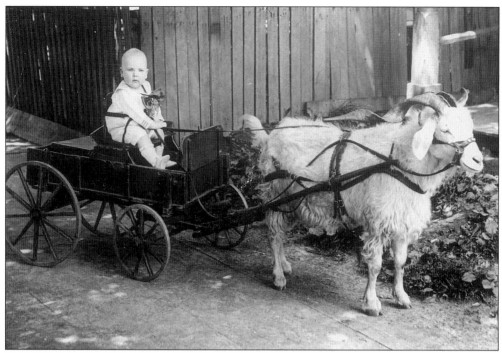

GOAT AND WAGON, 1924. Jack Rickey Jr. was pulled in a wagon. This 1924 wagon resembled the horse and buggies used for transportation a decade earlier.

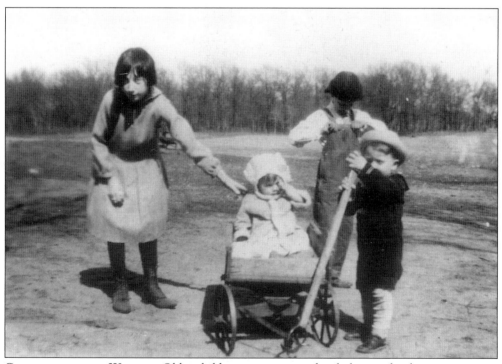

CHILDREN WITH A WAGON.. Older children were expected to help care for the younger ones. Pulling a small child in a wagon was a common sight.

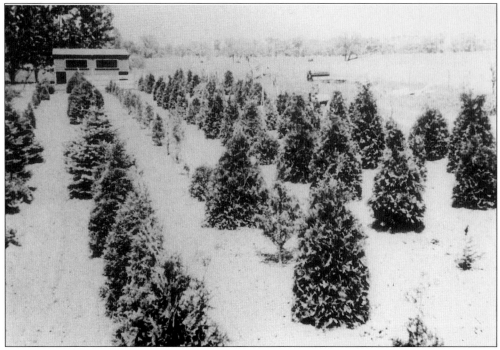

SEABLOOM NURSERY. This winter picture showed rows of evergreen trees growing at the Seabloom nursery The nursery was at the intersection of Highways 96 and Hodgson Road. Much of Mounds View Township was either flat or marsh land. Cranberries grew in some of the marshes. The people of the township named the numerous drainage ponds.

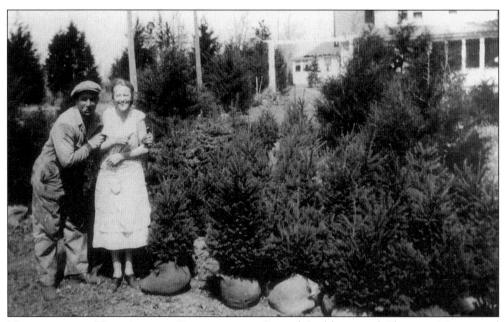

NURSERY WITH HOUSE IN THE BACKGROUND. Conrad Seabloom and Christine Moga stood beside bound trees ready for delivery. The house can be seen in the background.

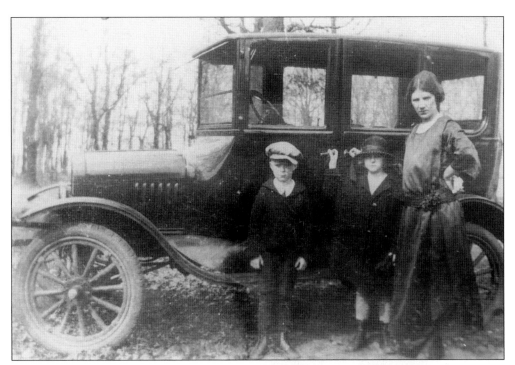

FAMILY CAR. On September 5, 1923, Pauline Schifsky posed in front of the family car with Bob and Dorothy, two of her children.

TRIPLETS. In 1929, Lena (Pauline) Schifsky stood with her three-year-old triplets Roger, Rosemary, and Richard Schifsky. During World War II, Roger served with the Ninth Army in Germany, Richard was a hospital apprentice in the Navy and Rosemary worked for an insurance company in Saint Paul. Another brother, not a triplet, Robert, was in the Army Air Force.

SHOCKING CORN STALKS. After the corn was removed from the stalks, the stalks were shucked and left in the field to be picked up and put in the barn or silo for cattle feed during the winter. Augusta and Ernest Larson rested by the shucked corn.

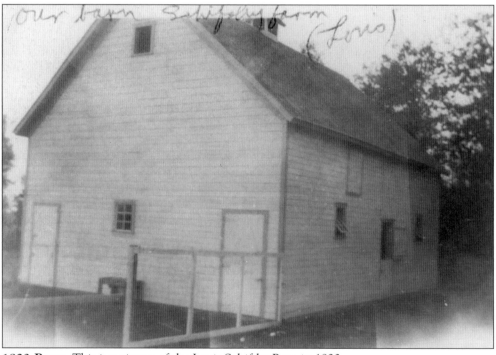

1923 BARN. This is a picture of the Louis Schifsky Barn in 1923.

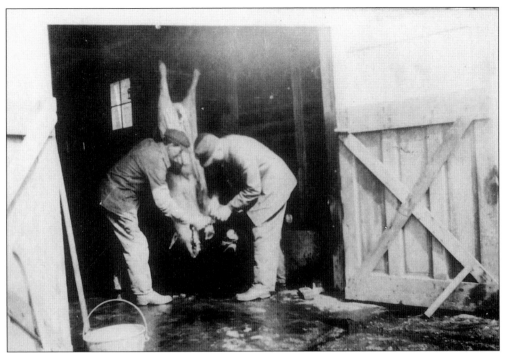

BUTCHERING A PIG. Some of the farms were pig farms. The farmers of the area grew or raised most of their food. They butchered the animals for meat and rendered the fat into lard The women canned the produce from the large gardens to be used during the winter.

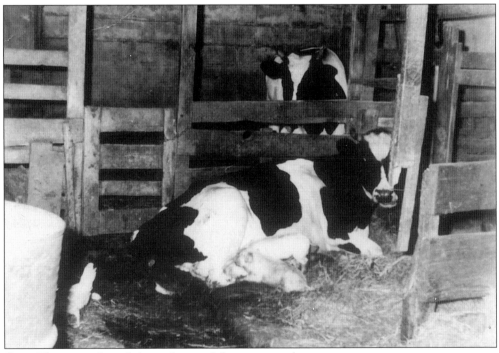

COW. This cow adopted the piglets as if they were a calves.

KENYON FARM. This was the farm home of Guy (Jack) and Minnie (Karth) Kenyon on North Lexington as it looked in 1928. In addition to dairy cows, they raised chickens and turkeys. They occupied this house from about 1925 to the early 1950s, when the State of Minnesota condemned the land and forced them to move.

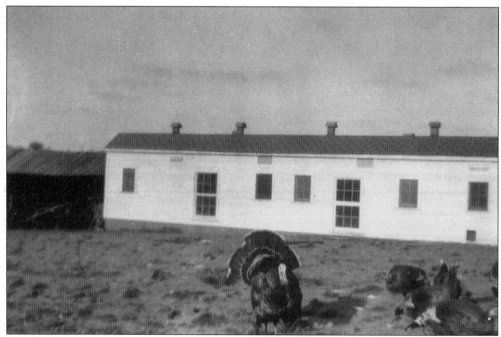

KENYON TURKEYS. The Kenyon's raised turkeys on their farm. The turkeys stood in front of the turkey house.

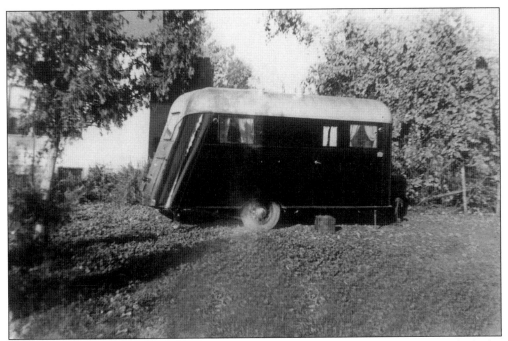

EARLY RECREATIONAL VEHICLE. This was an early recreational vehicle. The individual who owned this camper probably used it to go on trips or camping.

CABIN LOOKS LIKE A HOUSE. Many of the cabins on the local lakes resembled houses. As the area became more populated, the cabins were converted to year round residences.

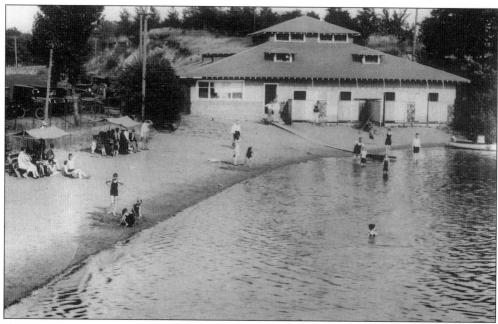

'SEE-ME BATHING CLUB. Pictured is the 'See-Me Bathing Club on the peninsula between Lake Wabasso and Lake Owasso. It was also known as the Velvet Inn and featured dancing, ice skating (in season), and "eats year round." Bus service from the Saint Paul depot was provided.

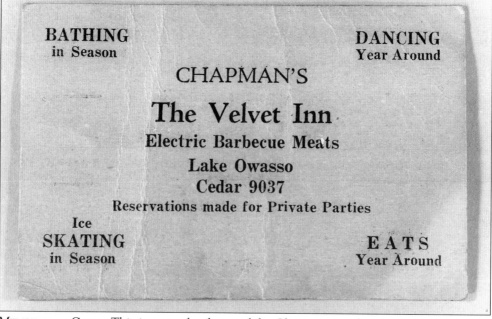

MEMBERSHIP CARD. This is a membership card for Chapman's Bath Club. In the 1920s, he planned a hotel and amusement park. Stock was sold but the project was not completed because of the stock market crash. In the 1930s, the club became the Hawaiian Night Club.

H. H. CHAPMAN,
PRESIDENT-TREASURER

M. CHAPMAN
VICE PRESIDENT-SEC.

CHAPMAN AMUSEMENT PARK CLUB
(INCORPORATED)

Bathing
Dancing
Skating
Picnic Grounds
—
BOARD of DIRECTORS
J. A. Newman
Geo. L. Lininger
Orvil W. Hart

LAKE OWASSO
NAMPAHC HOTEL

Sunday School - 9 a. m.
Church Service - 10 a. m.

Moving Picture & Vaudeville

A Good Place To
Bring Your Family
To
Keep ⎰ Cool
Keep ⎱ Clean
Keep ⎰ Coming

CHAPMAN AMUSEMENT PARK. The Chapman Amusement Park sold stock and was scheduled to open as part of the Bath Club Complex and across the street from the Velvet Inn. The all-inclusive undertaking, everything from church services to vaudeville, never got past the driving of the pilings for the building.

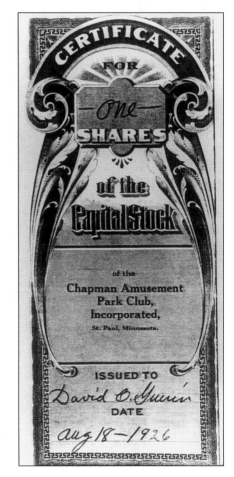

CHAPMAN STOCK CERTIFICATE. Stock certificates, dated August 18, 1926, were issued and sold. After the stock market crash, the project was abandoned.

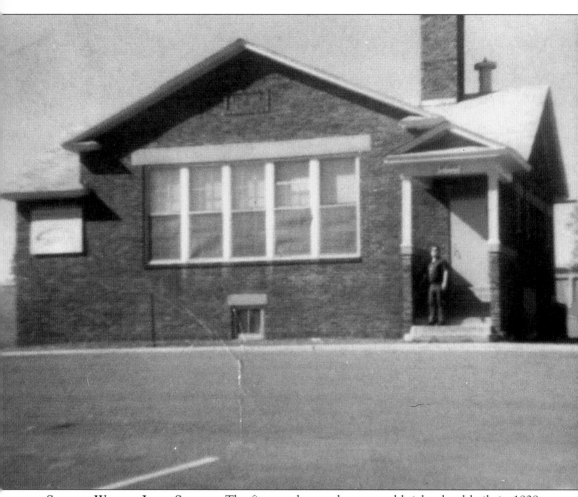

Second Wilbur Lake School. The first teacher at the new red brick school built in 1929 was Miss Rose Oske. She left a lasting impression by organizing the first 4-H Club called "The Wilbur Workers." The children competed with other schools in volleyball and dodge ball. In addition to their studies, they danced the "Hokey Pokey" and the "Virginia Reel" in the basement of the school.

SNAIL LAKE SCHOOL IN THE 1930S. This red brick school was built in 1930 on the corner of Highway 96 and Hodgson Road, and the name changed from the Hill School to the Snail Lake School. It was a two-story building with a principal's office, teacher's lounge, a lunchroom, and stage in addition to the two classrooms. In those two classrooms there were 48 students in 8 grades. On Monday after the yearly booya, the leftovers were served for hot lunch. The teacher was paid $125. Coca-Cola bottle caps were collected to buy writing paper, rulers, and pencils.

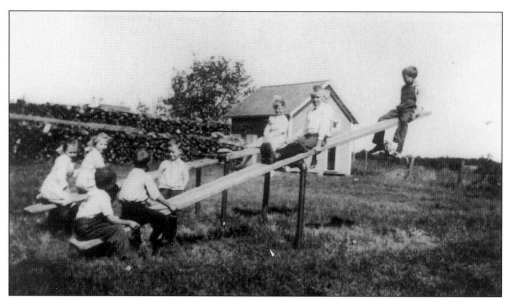

CHILDREN PLAYING. The children playing on the teeter-toters were not identified. The children also played games. The wood pile behind them was to heat the school during the winter.

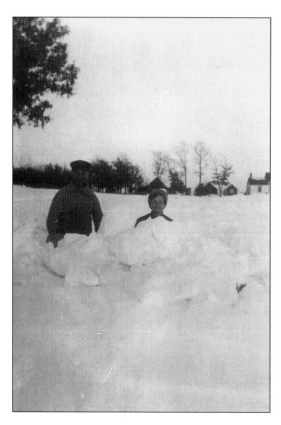

SNOW FORT. Popular winter activities for the children were sliding in the snow, skating, and building snow forts.

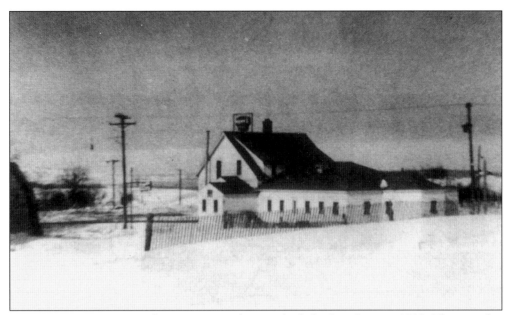

TURTLE LAKE TAVERN. The tavern complex was built by Ray Sina in 1932. The complex included an ice house, gas station, an all night restaurant, a dance hall, and a tavern. The tavern was razed in 1941 to allow the expansion of the roadway to accommodate vehicles transporting wartime ammunition from the Army Arsenal.

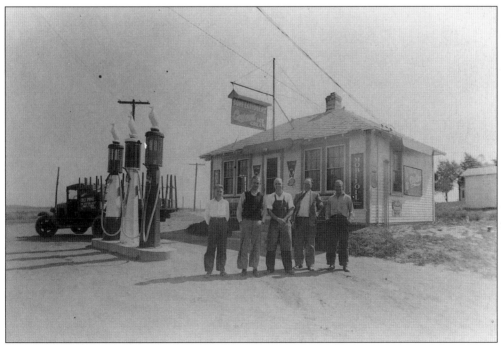

GAS STATION. This gas station was a part of the Turtle Lake Tavern Complex built by Ray Sina. The men were unidentified.

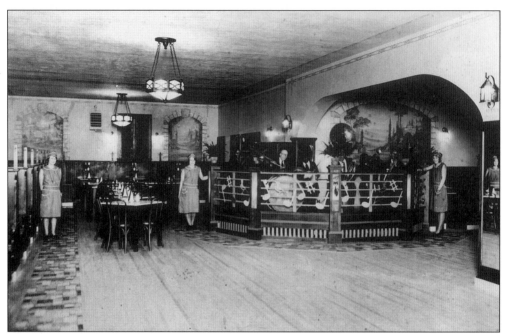

SLATTER'S NIGHT CLUB. Pictured is the band stand and the dance floor of Slatter's Night Club. It was also known as the Paramount. The woman on the right is identified as Frances Fabianski. The other names are unknown. There were several Night Clubs in the area that became Shoreview. The Owasso Garden, Breezy Point, and the Stumble Inn were some of the other bars in the area.

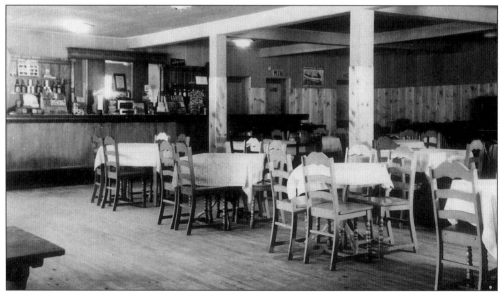

HAWAIIAN NITE CLUB. In 1934, the Hawaiian Nite Club was operated at the old site of the 'See Me Bathing Club. The tables at the Hawaiian Nite Club had checkered table cloths of red, blue, green, and white. In the 1940s it was the Manhattan Inn. The Lake Owasso Improvement Association sponsored a teen club. On Friday night, the teens paid a ¢10 admission charge to party and dance.

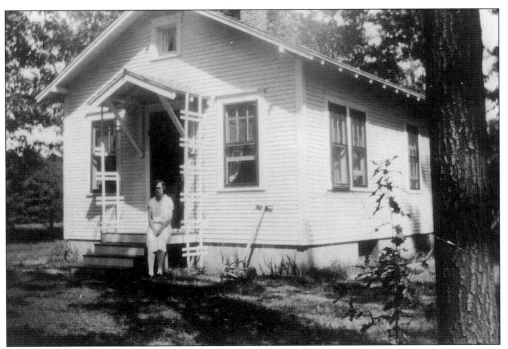

HOME BUILT IN 1927. The Hilmer Seabloom home was built in 1927. Gladys Seabloom sat on the porch of the home. The address was 5036 North Lexington Avenue.

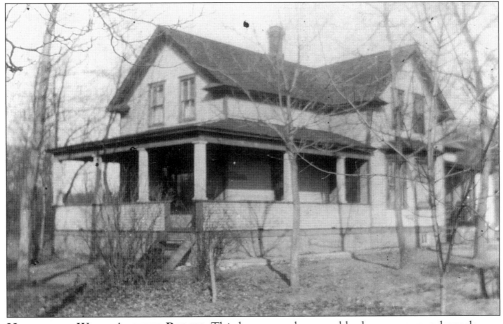

HOME WITH WRAP-AROUND PORCH. This home was large and had a wrap-around porch.

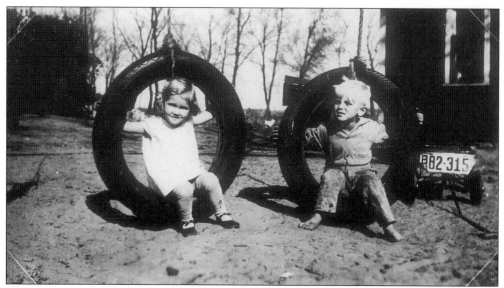

TIRE SWINGS. In September of 1934, Betty and Bob Bucher enjoyed swinging in the tire swings. This was a common use of old tires.

SCHIFSKY'S TURTLE LAKE BEACH. This beach was typical of the beautiful beaches in the area. The children and adults swam in the summer and skated in the winter. In the winter, there was ice fishing.

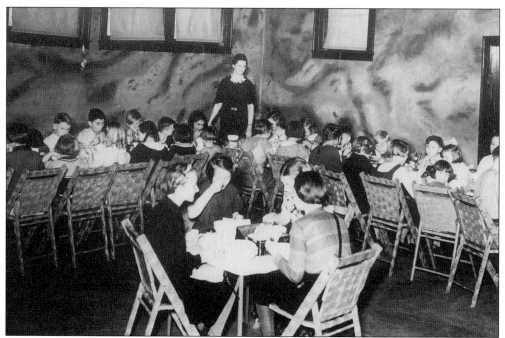

SCHOOL LUNCH. The children and teacher took their lunch break in the cafeteria of the Snail Lake School, District 28, in 1935. One teacher supervised the children while the other teachers and students ate their lunch.

SNAIL LAKE LADIES AID. This meeting of the Snail Lake Ladies Aid was held at the Marion Lundberg Home. Front row: Ruby Rasmussen, Marion Lundberg holds the cake, Elvera Alexander (Ray Lundberg's mother), Anna Zchiesche (Gladys Seabloom's mother) and Pastor Robert Kugler. Standing: Mrs. Harold Holstrom, Mrs. Effie Hall, Elaine Kugler, Peggy Meyer, Mildred McKinney, Gladys Seabloom, Mrs. Schroeder, Melba Slipka, Mrs. Carl Storner.

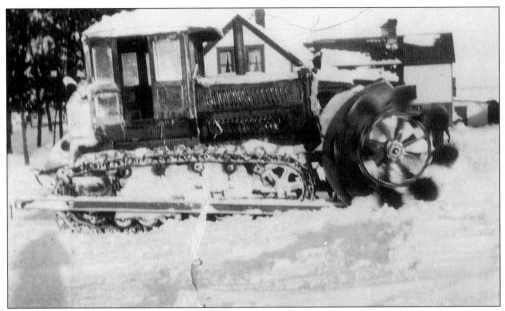

SNOW PLOW. This snow plow stopped in front of the Fabianski home in 1937. Snow plowing the roads began about 1928. Before 1928, the roads were mostly two ruts. They began to surface the roads with gravel about 1928 and soon after that they started applying asphalt to the roads.

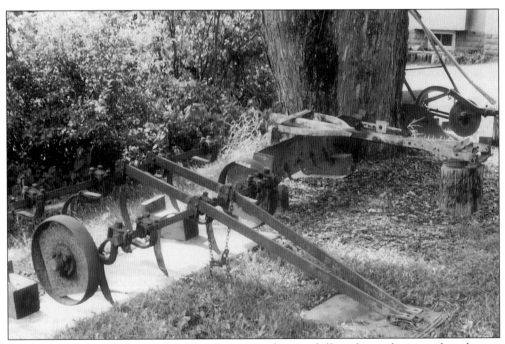

FARM MACHINERY. The activity of farming required many skills and varied pieces of machinery including this McCormick cultivator.

RESIDENCE, 1938. In 1938, the only residence between County Road G2 and County Road I was this home belonging to John (Jereczek) Rickey. Most of the area that became Shoreview was at that time still farm land.

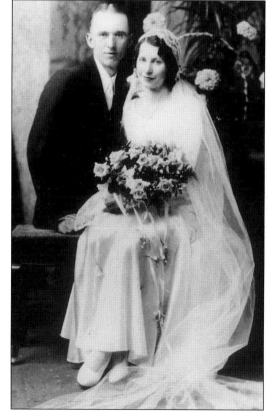

WEDDING, 1930s. This was the wedding of Helen Trojanowski and Edward Woida. Helen was the daughter of Frances (Moga) and Andrew Trojanowski. After they were married, they lived in Minneapolis and came out regularly to check on their farm that was between Lexington and Hamline Avenues.

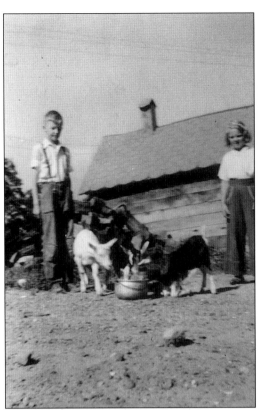

CHILDREN AND GOATS. Edward and Amelia Karth fed the goats by the milk house and pump. Most farm homes had a milk house and pump in the yard or a pump house.

AT CARDIGAN JUNCTION. Three unknown children played behind the Cardigan Junction building. The buildings in the picture were the pump house, a storage building and an outhouse behind Cardigan Junction. The pump house provided water for the steam engines and the family quarters.

CONFIRMATION. Mae Louise Holmberg was born May 13, 1925, and confirmed in the Mounds View English Lutheran Church on the 29th of August 1937.

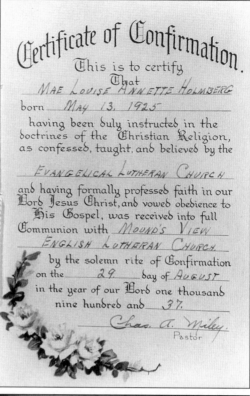

Certificate of Confirmation.

This is to certify That

MAE LOUISE ANNETTE HOLMBERG

born MAY 13, 1925

having been duly instructed in the doctrines of the Christian Religion, as confessed, taught, and believed by the

EVANGELICAL LUTHERAN CHURCH

and having formally professed faith in our Lord Jesus Christ, and vowed obedience to His Gospel, was received into full Communion with MOUND'S VIEW ENGLISH LUTHERAN CHURCH

by the solemn rite of Confirmation on the 29 day of AUGUST in the year of our Lord one thousand nine hundred and 37.

Chas. A. Miley
Pastor

CONFIRMATION CLASS. The 1937 confirmation class at Mounds View English Lutheran Church gathered around Pastor Miley. The other individuals were unidentified.

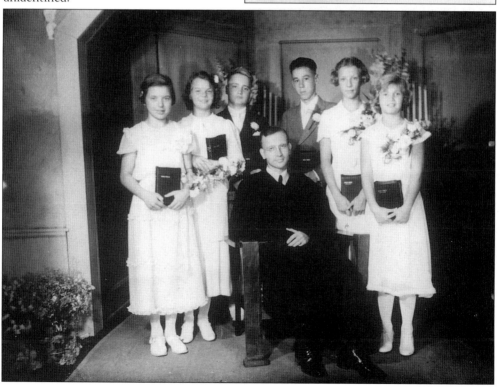

CHEVY TRUCK. Harold Lundberg sat in the Chevy truck he used in his landscaping business. His landscaping business was one of the first businesses other than dairies in the area that became Shoreview.

SEABLOOM MILK TRUCK. Hilmer Seabloom built the body on his milk truck. He used it to pick up milk and deliver it to the Milk Co-op in Saint Paul.

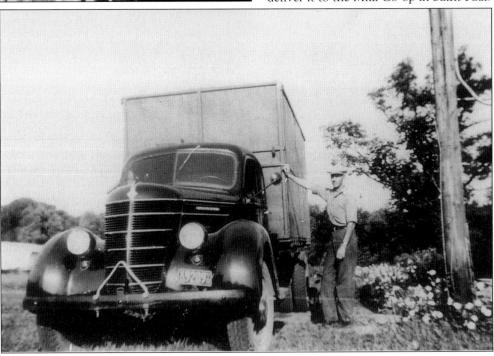

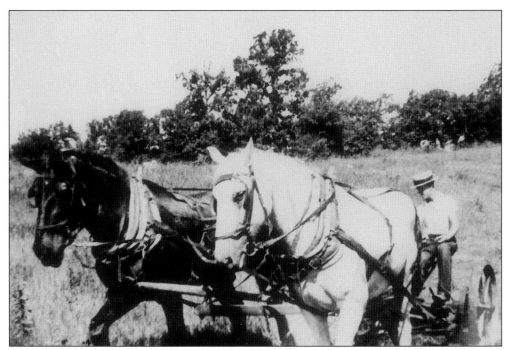

TEAM OF HORSES. In 1938 or 39, Howard Lundberg mowed with horses, Neig and King, on the 160 acres of the old Arden Farm was rented by his father, Peter Lundberg. That location is now the site of the Land O' Lakes Company.

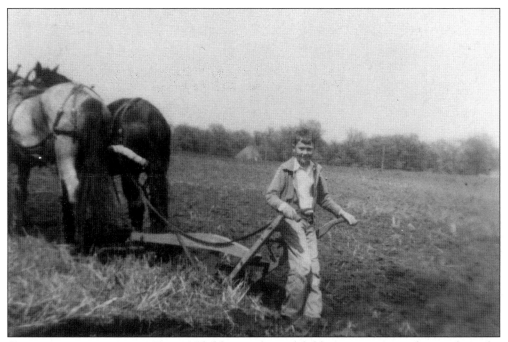

CHILDREN HELPED ON THE FARM. Children and grandchildren were expected to work on the farm. The boy with the team of horses and the plow was Bill Seabloom at age ten. This was his grandparents' farm.

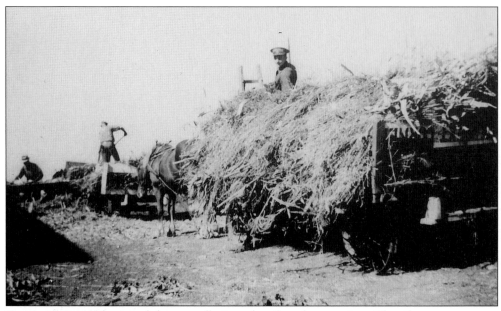

FILLING A SILO. The men fed corn stalks into the silo at harvest time. The silo was a common site on the farm and stored the corn stalks to be used as feed for the animals during the winter. The farmers raised and butchered their cattle or pigs for meat.

BRICK SILO. This brick silo was on the Dombrowski Farm.

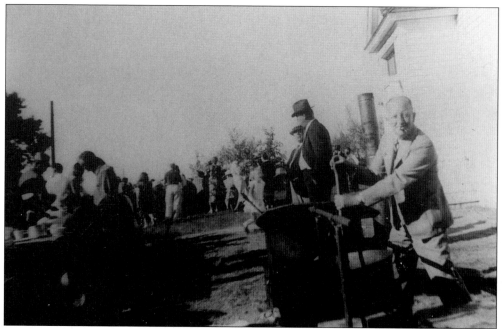

A BOOYA. Shown is the PTA Booya at Turtle Lake School District #35. Booya's are still common in the area surrounding Saint Paul. Many groups use the booya as a money making project. A large kettle, in the early years a 50-gallon drum in a water bath, was used to slow cook several kinds of meat and vegetables. Each group has its own closely guarded secret recipe.

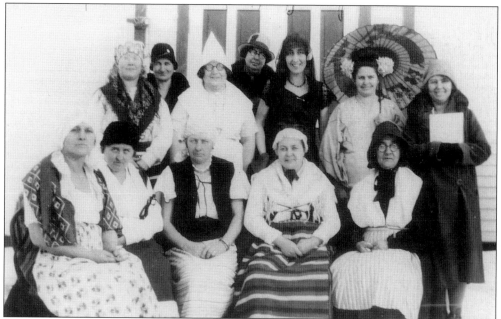

PTA AT TURTLE LAKE SCHOOL. This picture was taken at a March 1929 meeting of the Turtle Lake School Parent Teacher Association. A Scandinavian element to their dress can be seen. Front row: DeMars, Morrell, unidentified, unidentified, Bucher. Back row: Segelstrom, unidentified, unidentified, Thompson, Nord.

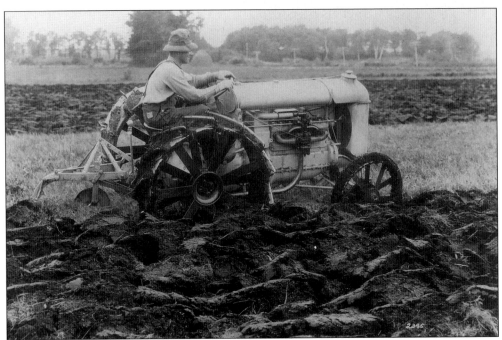

PLOWING WITH A TRACTOR. This farmer plowed with a tractor. The change to mechanization did not change the way the farmer dressed. The bib-overalls and hat were still almost a uniform.

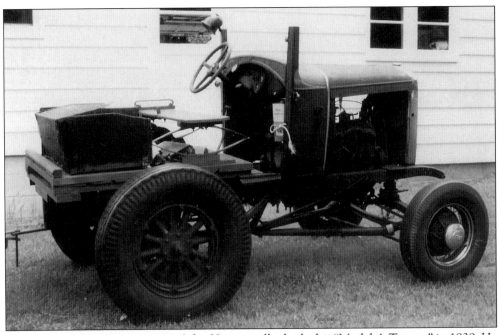

HOME BUILT TRACTOR IN 1939. John Haggenmiller built this "Model A Tractor" in 1939. He used a 1931 Model A engine and a car transmission, a 1923 Model T truck three speed transmission and a 1926 Model T worm truck differential. That gave him nine forward speeds and three backward speeds. It used brass gears and had 8.25 x 20 inch tires in back and 16 inch tires in front.

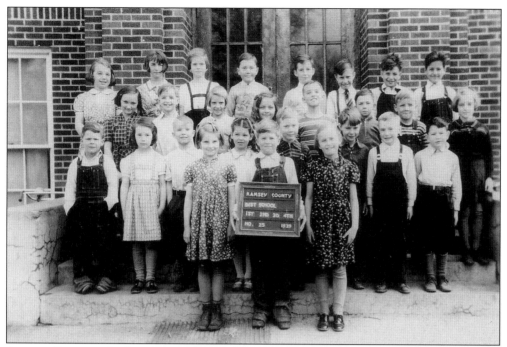

SCHOOL PICTURE. In the 1930s and 1940s, it was a common practice to take a class picture or in this case a school picture. The children are not identified. The plaque identifies this group as children from Ramsey County School District 25, grades 1, 2, 3, and 4 in 1939.

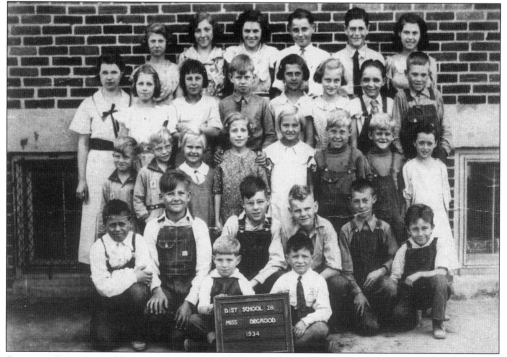

SCHOOL PICTURE. Class picture from School District # 28 in 1934. The teacher was Miss Decgrood.

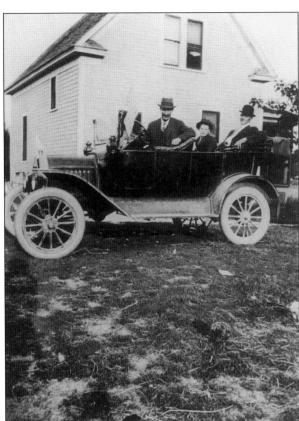

CAR. A car of the 1920s with several unidentified people.

PICNICS. Picnics were a popular recreational activity. They would pack a picnic lunch and drive to one of the local beaches .

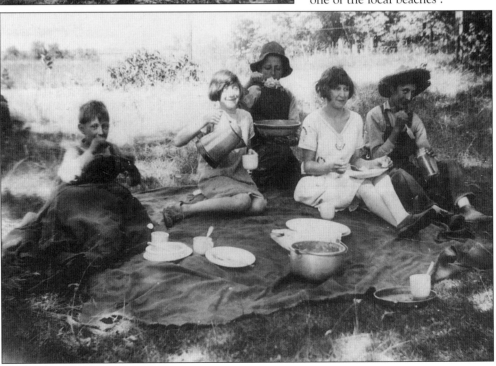

Three

1941–1956

MODERN CHICKEN COOP. The original Haggenmiller chicken coop stood next to the site of this one. This one was built in 1941 to replace a chicken coop twice its size that was the victim of an arson fire. Both chicken coops had running water from a well hand dug by Mr. Haggenmiller. The eggs were sold in local stores and the bars in the area.

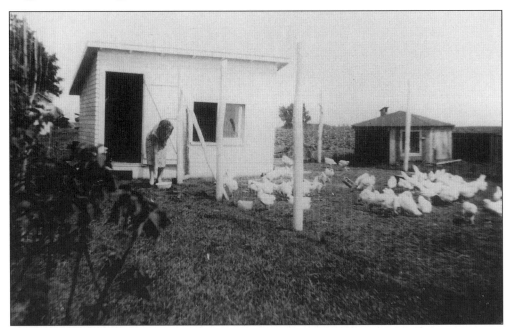

1940S CHICKEN COOP. Dorothy Sina fed the chickens in 1943. The dark building to the right was the incubator house. Light bulbs were used to provide the heat to hatch the chicks. Dorothy said the children "worked from the time they were dry behind the ears."

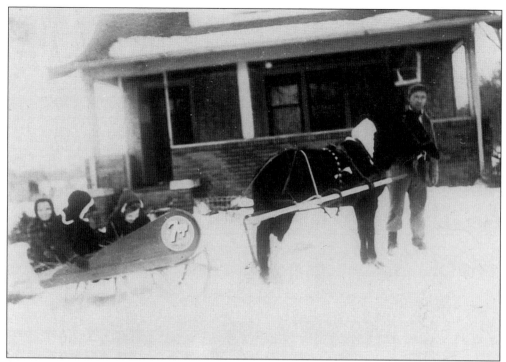

SLEIGH. Jim Crisham stands in front of his home holding "Babe's" reins. The sleigh full of children waited for "Babe" to pull them around their turkey farm on a cold and snowy winter day in the 1940s.

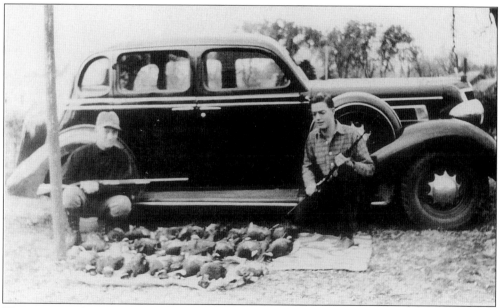

HUNTING. Carl Stutsman and his nephew Howard Broman knelt by the pheasants they bagged on a hunting trip. Birds were in season early in the fall and game animals later in the year. Hunting was a common activity in the fall and winter. In the spring and summer, fishing was popular. In the winter, they put up fish houses on the ice, cut a hole and fished through the ice.

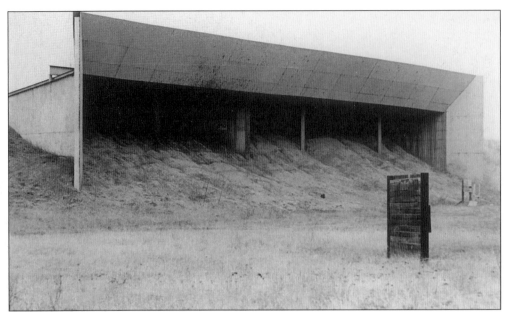

AMMUNITION TEST BUNKER. Pictured is a Range Bullet Catcher at the Twin Cities Army Ammunition Plant (also known as the Arsenal, the Army Ammunition Plant and the Arms Plant.). The ammunition was tested by firing it into bunkers like this one. Shoreview residents near the western border of Shoreview watched the tracer bullet. Arthur Nelson was killed by a ricocheting bullet fired at a bunker.

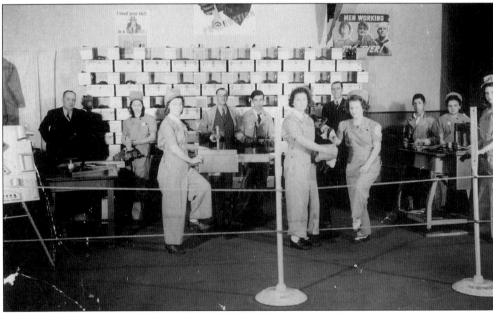

WOMEN IN WORLD WAR II. Women were active during World War II. These women graduated from a training class at the Army Ammunition Plant where ammunition was made. The only individual identified is Florence (Lackey) Lundberg, third from the left. Other women participated in the Lake Owasso "500" Club of the Lake Owasso Red Cross Unit. Due to gas rationing, they rode their bicycles to meetings at Rice Street and County Road E.

MILITARY SERVICE IN WORLD WAR II. Many of the men and women of Shoreview served in military services during World War II. Pictured is Jack Bussiere, a naval cadet.

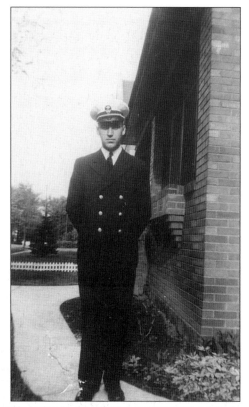

APPLYING FOR JOBS AT THE ARSENAL. These men were in line to sign up for jobs at the Twin Cities Army Ammunition Plant in the early days of World War II. The local people rarely called the plant by its correct name. Some of the common names were the Arsenal, Army Ammunition Plant or Arms Plant.

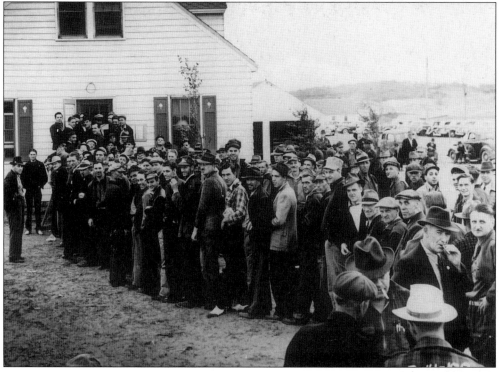

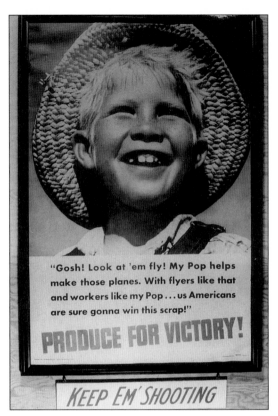

VICTORY GARDEN POSTER. There were many posters during the World War II era. This one showed a boy imploring the civilians to plant and cultivate "Victory Gardens."

"Gosh! Look at 'em fly! My Pop helps make those planes. With flyers like that and workers like my Pop...us Americans are sure gonna win this scrap!"

PRODUCE FOR VICTORY!

KEEP EM' SHOOTING

LARGE GARDEN. This typical home garden was located on the Carl (Charles) W. and Erna (nee Otto) Karth farm. The farmers of the area all had large garden to produce the food they canned for use in the winter. This location is now a shopping center at Lexington and Highway 96.

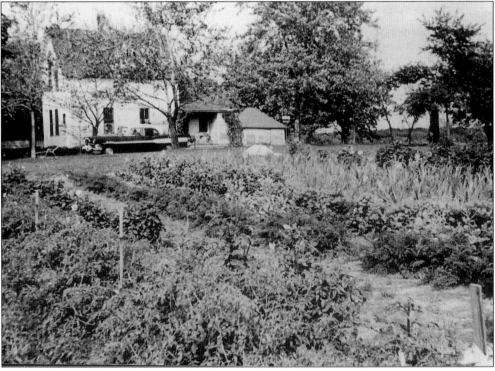

LAKE DISTRICT RECORD. This issue of the Lake District Record was reproduced on a hectograph. A hectograph was a duplication device. Typed or written matter was transferred to a glycerin-coated sheet of gelatin. When the master was removed, the paper to receive the image was placed on the gelatin and the writing or type was reproduced one sheet at a time.

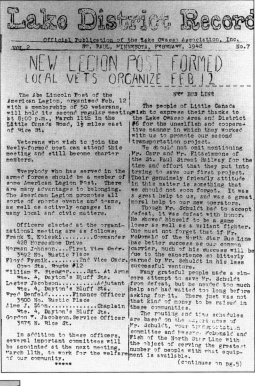

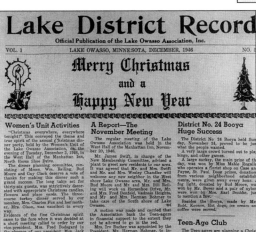

LAKE DISTRICT RECORD. This Lake District Record appears to have been reproduced on the other popular means of reproduction at the time, the mimeograph. To make copies with the mimeograph a stencil was cut. To cut a stencil, the information was typed on a stencil paper without ink. The stencil was then put on a round drum containing ink. A copy was produced with each turn of the crank

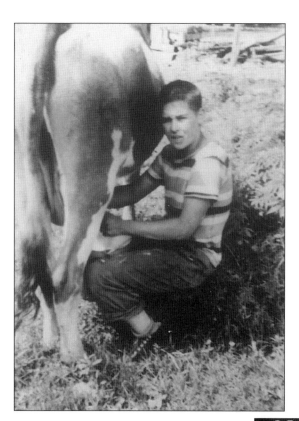

MILKING "PENNY" THE COW. Spike (Daniel) Crisham milked "Penny" on the Crisham farm. The farm children all had chores that needed to be completed before they played.

4-H. Pictured is the cover of a 4-H book from August 1, 1944. Because Mounds View Township was a rural farm community, many of the children participated in 4-H activities. Front row: Helen Hammerstein, Eleanor Leaner, Lylah Oberg, Mrs. Ed. Coulter (Ruth Isackson). June Rogalla, Mrs. Bernard Schifsky (Hildur Carlson), Earl Ford, Howard Lundberg (reading.) Back row: Leonard Nessel, Bernard Schifsky, Mrs. Earl Ford (Lillian Isackson.)

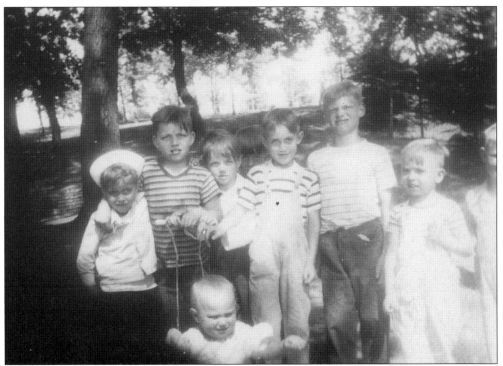

SCHOOL PICNIC. This picture was taken at the Wilbur Lake District #28 School in 1948. Baby Karen Hoff stood in front of the older children. Pictured are: Dick Nordin, Ken Hoff, Frankie Cooper, Howie Sinna, Timmy Peale, Howard Hoff, and Buddy Peale.

CHILDREN'S PARTY. These children were at a birthday party. They waited in line for a turn at the fish pond. Children often played games even when not in an organized group. Another frequently played game was called "statue." Music was played and the children danced. When the music stopped, they had to freeze in that position.

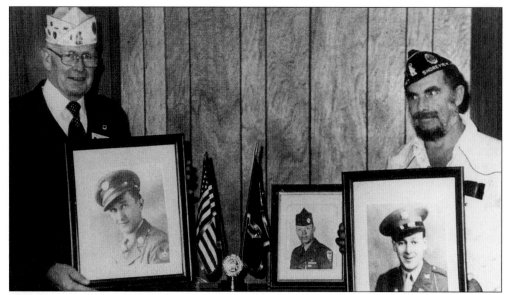

AMERICAN LEGION. Two Legionnaires of Shoreview showed pictures of World War II comrades. An article in the Lake District Record invited veterans to join the Abe Lincoln Legion Post. That Post is still active. In 1961, the Jacobson Memorial Post was chartered in Shoreview and is active. The Veterans of Foreign Wars Post 2609 is also active in Shoreview.

LAKE OWASSO GARDEN CLUB. The Lake Owasso Garden Club was started in 1947. They participate in the activities of the Minnesota Horticultural Society. The club celebrated its 50th year in 1997. They continue to have monthly meeting where they share information and encourage gardening as a hobby. Beginning in 1947, they have sponsored yearly flower shows.

BOY SCOUTS. Jerry Coleman congratulated Eagle Scout Steve Weeks. Boy scouting played an important role in the lives of the children. The 1947 Boy Scout Troop was sponsored by the School District 24 Parent Teacher Association. The Boy Scouts are still active in Shoreview.

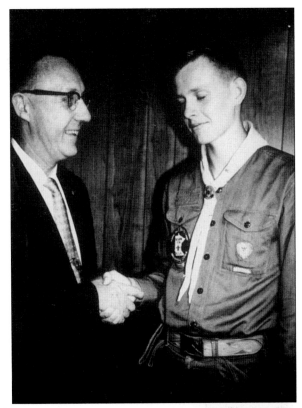

CHILD WITH A TEAM. This unidentified child helped on the farm at an early age by holding the team until the adult was ready to hitch up the wagon.

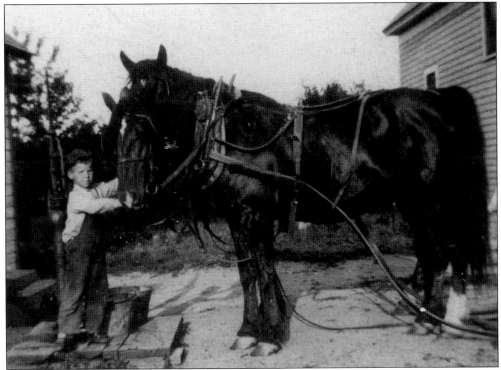

SUMMER COTTAGE. This summer cottage belonged to Laura Haggenmiller. It was typical of the summer cottages that were on the shores of the lakes in Shoreview.

SUMMER CABIN. This cabin was the Millette Cabin on the John Haggenmiller property.

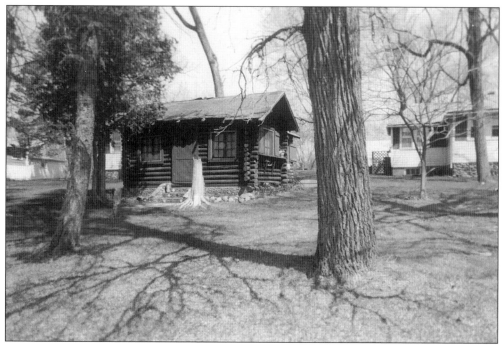

CABIN ON SNAIL LAKE. Many of the summer cabins were log cabins like this one. This cabin was on Snail Lake Road across from Snail lake.

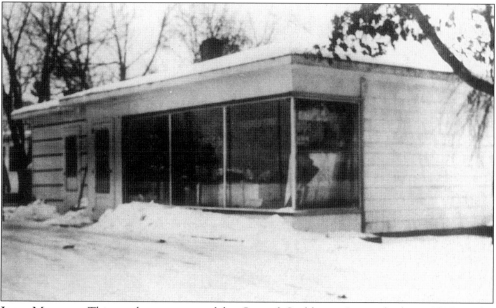

JIFFY MARKET. This market was owned by Conrad Seabloom. It was built in 1949 at the intersection of Highways 96 and Hodgson Road. During the forties, there were several small markets scattered around the area that became Shoreview. They sold ice, milk, and some groceries.

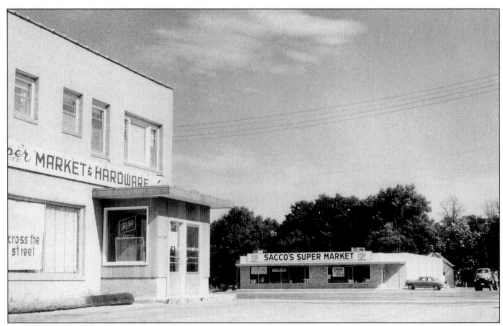

FIRST SACCO MARKET. After corresponding with his wife-to-be during World War II, Joe Sacco went to New York where they met and married. While an apprentice engraver, Joe Sacco remembered working in a grocery store as a teenager. Kay and Joe moved to Shoreview and started the market on the left side of the picture. They lived above that first store and worked long hours.

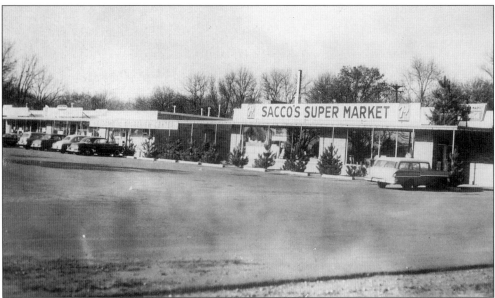

SACCO'S SUPER MARKET. Joe Sacco built the first Super Market in the first strip mall. They left an open space between Christianson's Pharmacy and Sacco's Super Market because there was an ordinance prohibiting strip malls. Except for a short affiliation with the SuperValu and Fairview chains, he operated the market as an independent until he sold it in 1959 and opened a business manufacturing precision parts.

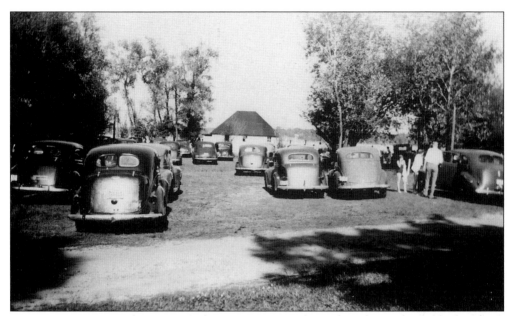

PUBLIC BEACH. On July 29, 1945, these cars were in the parking lot at the public beach on Turtle Lake. The building in the background was the bath house. This beach was off Lexington Avenue on Turtle Lake. Through the years, beginning in the 1880s, the beaches and lakes of the area continued to be popular attractions.

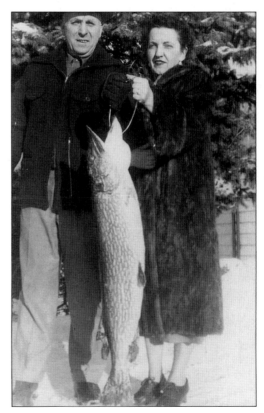

FISH CAUGHT IN TURTLE LAKE. Con and Betty Seabloom hold a fish caught in Turtle Lake in 1951. A muskellunge, in the 1940s and 1950s, had to measure at least 36 inches in length to be a "keeper." Resorts in the area date back to the 1880s. William Athey, who lived on the east shore of Snail Lake provided boats and fishing tackle. Patrick Powers rented boats and tackle on Lake Johanna.

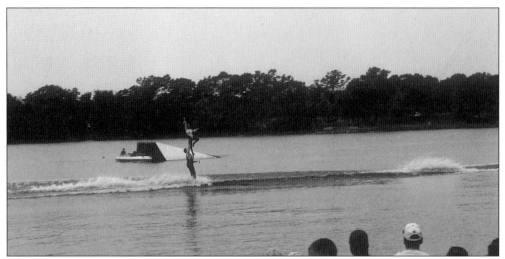

WATER SKIING ON SNAIL LAKE. Water skiing was and continues to be a popular sport on the lakes of Shoreview. These unidentified people were skiing on Snail Lake.

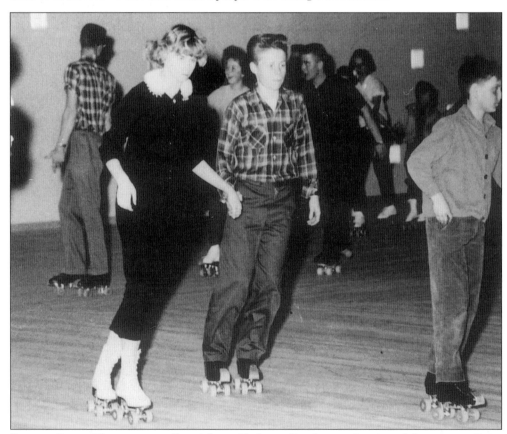

ROLLER RINK. There was a roller rink on Hodgson Road near the site of the current Dairy Queen. There was open skating and solo skating competitions. They had live music for dancing on the weekends. When they were not ice skating, the teenagers spent many hours enjoying the activities at the roller rink.

1953-1954 CONDEMNATION NOTICE. When the State condemned the property of the Island Lake area to develop a new highway, there were protests. The property at County Road E and Victoria Street, the site of the Ray Jensen Farm, was taken. Highway 694 was constructed and Island Lake Park was created. In July, Island Lake Park is the site of Shoreview's yearly citywide celebration, A Slice of Shoreview.

Condemnation Of Tract Protested

An official notice that the State highway department is condemning land at the newly acquired Island Lake park, County Road E and Victoria, for the construction of state Hwy. 10 was received today by the Board of County Commissioners.

The state notice says eight and one half acres will be taken in a strip crossing the county tract. The strip will cross the island located in the lake and will be used as the location of a new super highway entrance into St. Paul.

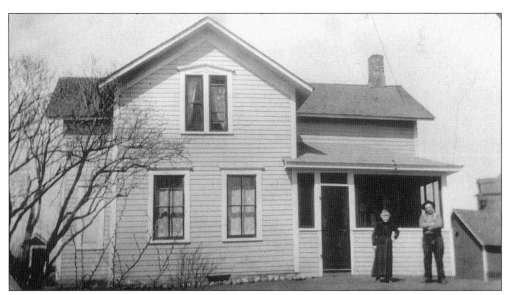

JENSEN FARM. This farm was bought by Marie and Jens Jensen in 1905. They were the parents of Ray Jensen. The property was condemned by the State to develop a new highway. When the development was completed, Highway 694 ran next to Island Lake Park in Shoreview.

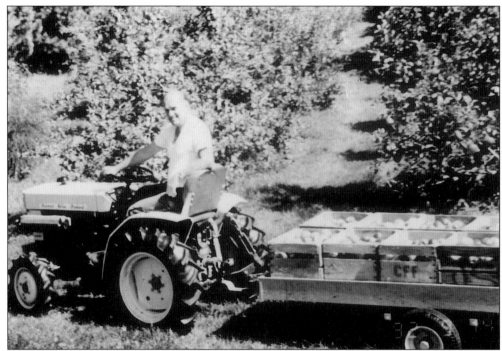

APPLE HARVEST. The date of this picture is unknown. Don Papenheim towed a trailer of apples with a tractor. Many of the farms had apple trees and some of the farmers grew apples as a crop. The orchard is now known as the Victoria Valley Apple Orchard.

1951 DESOTO CAR. This car was the first of the partially automatic cars. To go forward, it was put in drive and driven like the automatic of today. However, to back up , it was necessary to engage the clutch and shift like a manual transmission car.

Four

THE VILLAGE OF
SHOREVIEW

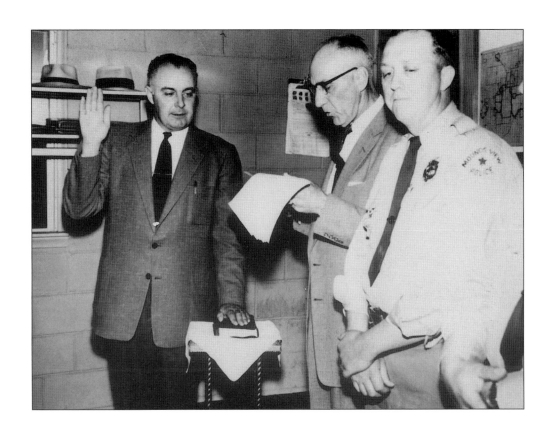

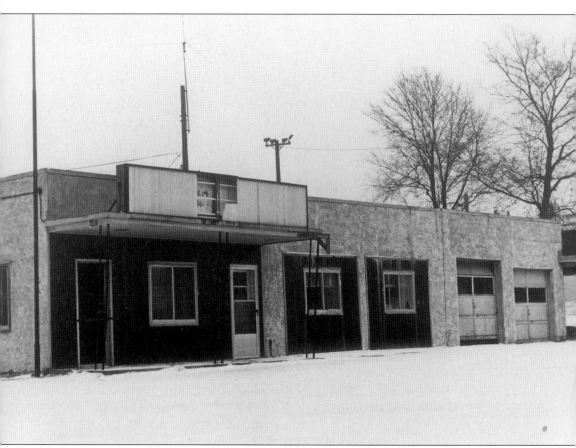

VILLAGE OF SHOREVIEW. Early on the Village had a housing problem. The first elected officers used Willis Wilson's chicken coop as a office. After a few weeks they met on the second floor above Mayor Hanold's garage. The ethics of renting from the Mayor was hotly debated. Fred Memmers, the Village attorney, found a "loop hole" in state law allowing an elected officer to take money from the municipality if no other suitable location could be found. However, the Minnesota Attorney General, Miles Lord, overruled him. The Union Gospel Mission offered to renovate a space for them to meet. That possibility was also declared illegal. Mr. Blaisdell and Mr. Breithbarth learned that Leo Sinna had removed the second floor of his barn and added a flat roof. It became the Village Hall until they outgrew it.

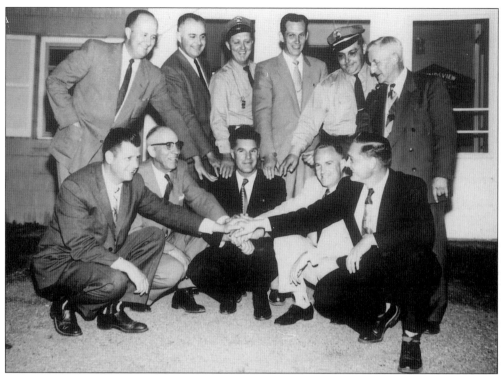

FIRST VILLAGE OFFICERS. These were the first elected officers of the Village of Shoreview. Front Row: Trustee Max E. Tyler, Village Clerk Willis A. Wilson, Mayor Kenneth Hanold, Trustee Godfrey J Pyle, Trustee Harold R. Koeck. Back Row: Justice of the Peace John Wallraff, Deputy Clerk Reuel Breitbarth, Constable Cyril Olund, Justice of the Peace Floyd Olesen, Constable George E. Gagnon, Treasurer Ed H. Sitzer.

LOAN OFFICE. With the incorporation of Shoreview in 1957, there was an influx of people. That influx of people brought urbanization to the mostly rural area. The Wilson Loan Office opened and people began moving to the second ring suburb of the Village of Shoreview

ANOTHER VILLAGE HALL ON HIGHWAY 96. Originally, this was the Frank Sinna home. Due to an explosion, the house had been blown apart. Leo Sinna, Frank's son, rebuilt it. After a special election, Frank Sinna sold the house to the Village. By 1961, the Village of Shoreview had grown enough to need both the space in the converted barn and the restored house.

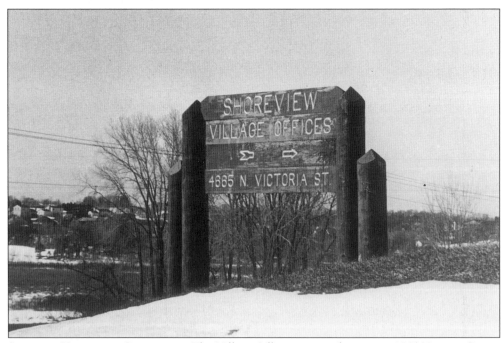

SIGN FOR VILLAGE OF SHOREVIEW. The Village Offices sign can be seen at 4665 Victoria Street. The sign was erected across the street from the present City Hall and Community Center.

CITY HALL SUPPLIES. The closet of the house the Village used for offices was utilized as the storage room. Because space was limited, they used the bathroom as a back up location to store records.

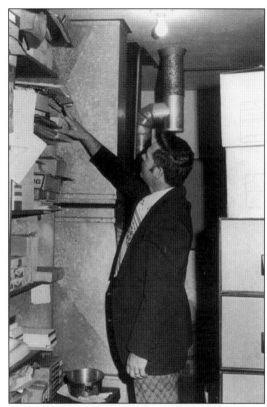

COUNCIL MEETING. Shoreview Council met in the old village hall in 1972. Shown are: Tom Wegleitner, Jim Olson, Jerry Filla, Bill Farrell, Richard Hogan, Rollin Stauff, Dick Wedell, Jim Nervig.

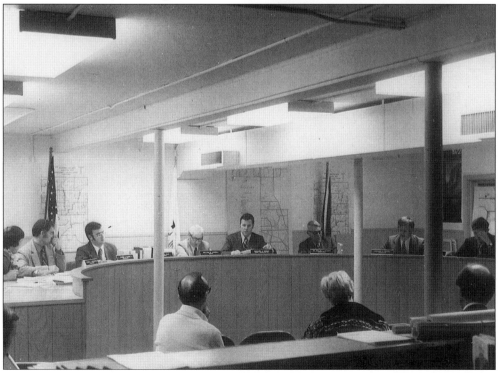

DRIVE-INS. In the 50s and 60s the only drive-in type foods available were the A & W on Rice Street and the Dairy Queen on Hodgson Road. That was the situation until well into the 1980s.

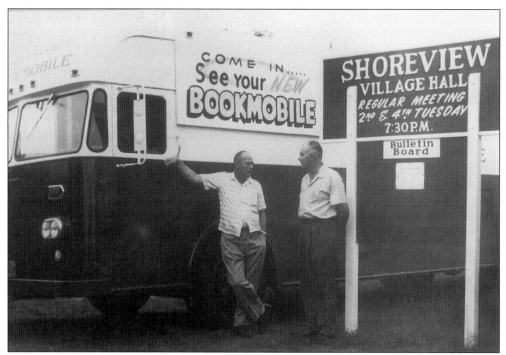

BOOKMOBILE. One of the Ramsey County Bookmobile stops in the 1960s was the Village Hall. They made regular rounds every two weeks. If someone wanted to add a stop, they called the library and requested the stop be added.

116

DRIVER'S TRAINING RANGE. This was the Grand Opening of the first Driver's Training Project in the area. It was on the Carl Holmberg land and used by the police as well as civilians. Some of the signs along the route were "Watch for Children," "Speed limit 10 MPH," "Do Not Enter" and "Stop." Shown are Mayor Ken Hanold, his son Gregory, Sheriff Kermit Hedman, and Karin Holmberg, daughter of Jean and Carl Holmberg. Courtesy of Nick Berkowski.

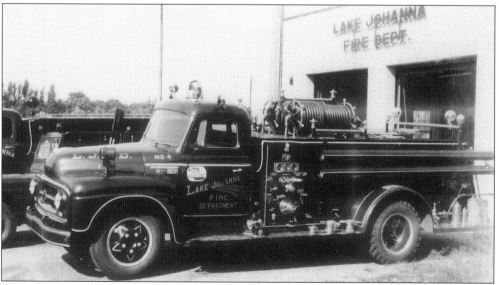

VOLUNTEER FIRE DEPARTMENT. The fire station behind the fire truck is Lake Johanna Fire Station # 4 at 3246 New Brighton Blvd. That station was dedicated in 1946. Because the telephone of the fire department rang in each fireman's home, someone had to be at the volunteer fireman's home to respond to the call. They responded by pushing a button to indicate they had received the message.

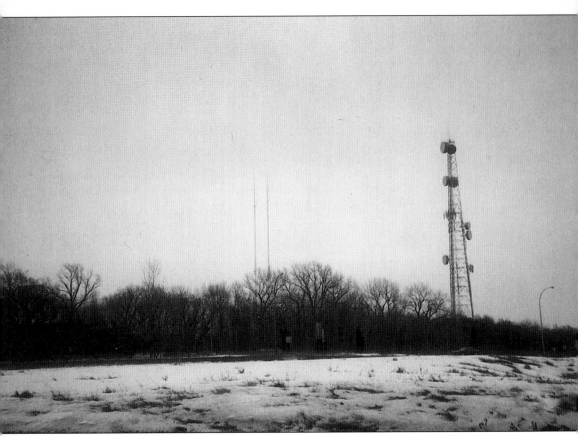

TELEVISION AND RADIO TOWERS. The Shoreview Telefarm just north of Highway 694 is a landmark seen for many miles. The towers are the tallest things around. When local people think of Shoreview, they think of the "community with the tall towers," or ask, "Isn't that where that tower fell down years ago?" The towers had a tragic beginning. It was in September of 1971, while a large platform was being hoisted to the top of the tower, the tower collapsed. The collapse of the 1466-foot tower killed 6 men on the tower and one man on the ground. After the removal of 500 tons of steel wreckage from the site, that tower was replaced by 2 towers. Each of the new towers is 1375 feet tall. The new towers have a tiny elevator that goes most of the way to the top.

Five

THE CITY OF
SHOREVIEW

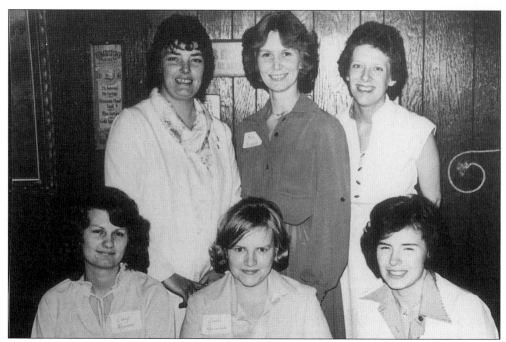

JAYCEES. During the 1970s, the Jaycee's were very active in the Community of Shoreview. Jaycee Women Officers: (front row) Cheryl Bortan, Connie Kummweide, and Joyce Tjorvick; (back row) unknown, Sally Sundberg, and Lois Bossert.

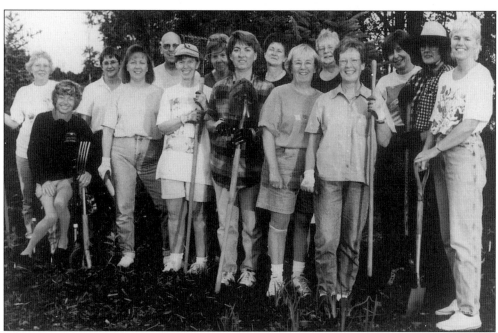

SHOREVIEW COMMUNITY GARDEN CLUB. These club members planted a new Wild Flower/ Native Garden to help promote civic beauty and educate members and the public. Individuals were not identified. In the spring, the club helps the city plant and maintain their annual planting. Tomi McLellan and Karlyn Kaus-Wegmann started the club.

TURTLEMAN'S TRIATHLON. Community spirit continues to be active in Shoreview. The first Turtleman's Triathlon was held in 1978. It begins the evening before with a creamette/ clasico buffet. Competitors swim .78 of a mile, bike 21.3 miles, and run 4.7 miles. The race can be done as a relay or individual race. Participating as an individual, the racer would qualify for the Tri/Fed USA International Distance Championships.

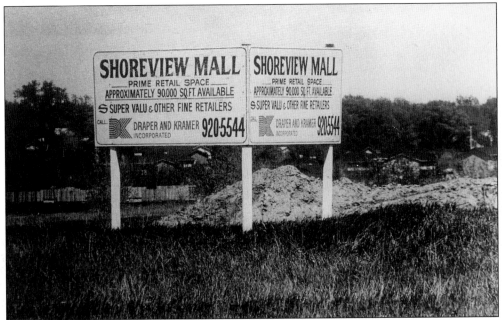

FIRST SHOPPING CENTER. Until Shoreview Mall was started in 1980, there was an ordinance prohibiting strip malls in Shoreview. Sacco's market and Christianson's Pharmacy had solved the problem by leaving an open space between the stores.

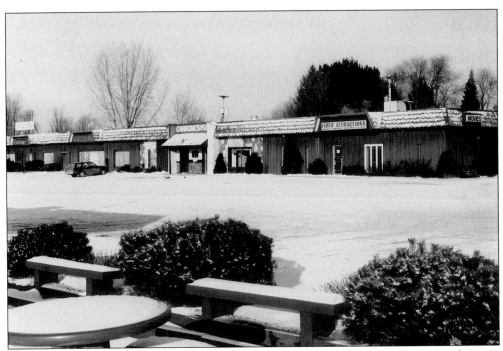

SHOPPING MALL. This shopping mall was next to the Dairy Queen on Hodgson Road. It was erected in the mid 1980s and demolished in 1995.

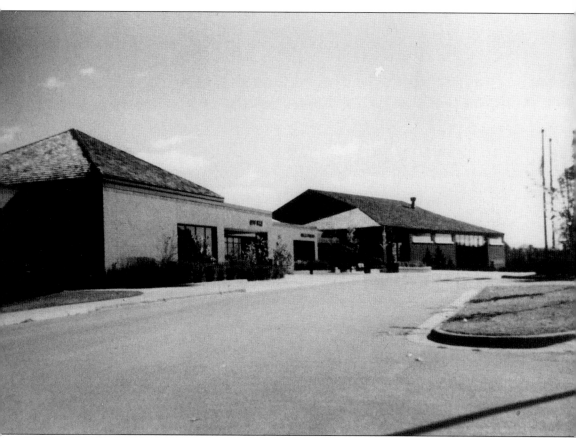

SHOREVIEW COMMONS. Shoreview Commons is unique in that it is a City Hall, Library, Community Center built in a park specifically created to serve as the center of the City of Shoreview. Shoreview Commons became a reality in 1990. The road to a city hall had many setbacks and problems. Bill Farrell became Mayor in 1970. As had the mayors before him, he began lobbying for a "proper" city hall. Dick Wedell, the Mayor when the city hall was built, was quoted as saying at Shoreview's fortieth anniversary, "We were having a terrible image problem. How do you sell the (Village) to a business when you're working in a bungalow that's not air conditioned and storing your record keeping in a bathroom?" After a number of defeats, the referendum to fund the building of a city hall passed by a single vote on July 17, 1975. The vote was challenged, but was upheld in the court. Shoreview not only has a "proper" city hall, it has a state of the art Indoor Tropical Water Park.

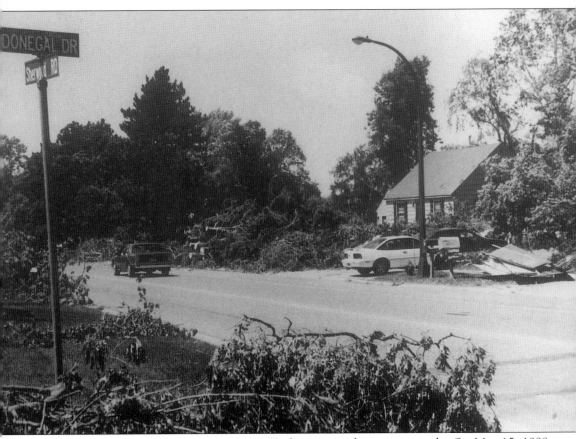

TORNADOS IN 1965 AND 1998. In 1965, there was a damaging tornado. On May 15, 1998, another tornado ripped through Shoreview causing serious damage. The Lake Johanna Volunteer Fire Department and departments of surrounding suburbs came to the aid of Shoreview in cooperation with the Ramsey County Sheriff Department. Police services are provided by the Ramsey County Sheriff Department.

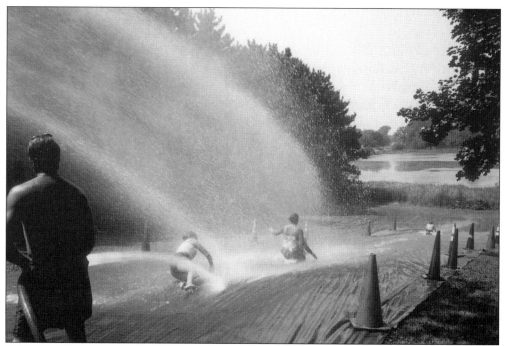

A SLICE OF SHOREVIEW. The lakes of Shoreview make it essential that a water slide be a part of Shoreview's summer festival named "A Slice of Shoreview." It is held the last week of July at Island Lake Park.

A SLICE OF SHOREVIEW. Of course, the parade is only one of the continuous events happening during the Slice of Shoreview celebration. The Norther Lights Variety Band performs several times during the festival.

Number	Site
1	School District #4
2	Marsden (Seabloom) home
3	Bucher Farm
4	Kath (Karth) home
5	Cardigan Junction
6	Wilbur Lake School
7	Hill Farm School
8	Turtle Lake School
9	Art Larson home
10	Childern's Preventorium
11	Snail Lake Tavern
12	Bethany Church
13	Union Gospel Mission
14	Ernest Larson farm
15	Kurkowski farm
16	People's Ice & Coal Company
17	Schifsky home
18	Kinberger barn
19	Dombroski farm
20	Bye farm
21	Kuehme farm
22	John (Jereczek) Rickey home
23	Carl Holmberg home
24	Old Spinning Wheel -Jiffy
25	Guerin Gas Station
26	Thompson's Store
27	Tobin's Store
28	Seabloom Nurery
29	Dillinger house
30	See-Me Bathing Club
31	Wilbur Lake School
32	Snail Lake School
33	Turtle Lake Tavern
34	Slatter's Night Club
35	Turtle Lake Beach
36	Haggenmiller property
37	Arsenal
38	Sacco's Market

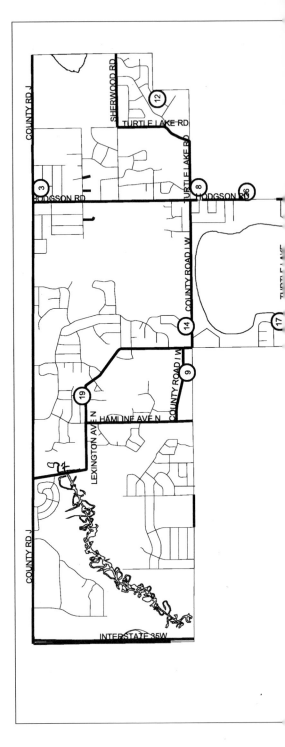